# The Secret Surrealist

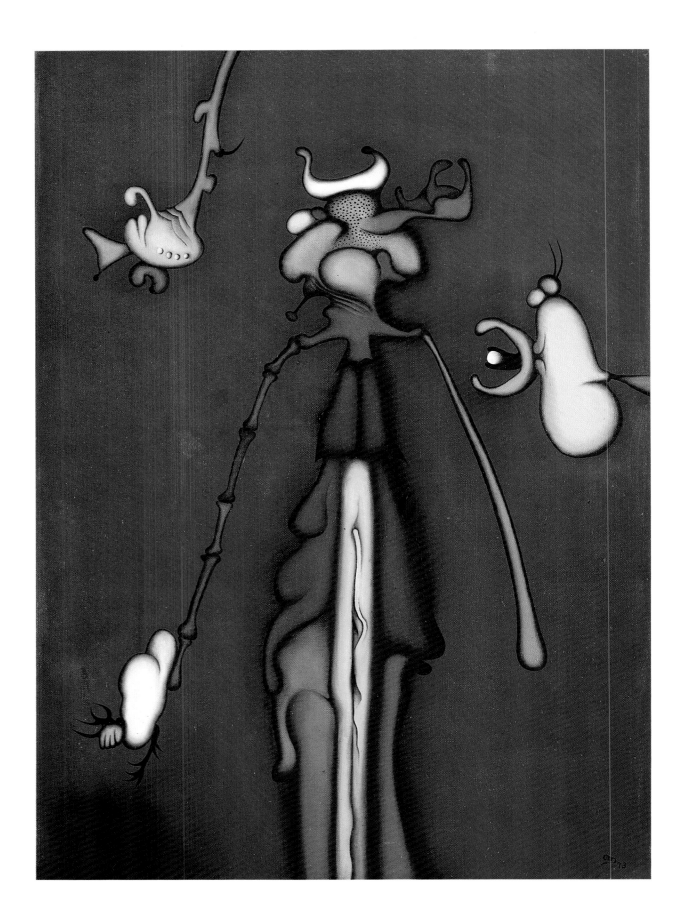

# The Secret Surrealist
## *The Paintings of Desmond Morris*

Desmond Morris
with an introduction by Philip Oakes

Phaidon · Oxford

# Acknowledgements

Many people have helped, either directly or indirectly, with the realization of this volume. They include, in particular, Rosemary Amos, Sir David Attenborough, David Blest, Hugh Clement, Paul Conran, Richard Dawkins, Michael Dexter, Marcel Fleiss, Alasdair Fraser, Herman Friedhoff, Philip Guiton, Fae Hall, E.V. van Hall, Denise Hardy, Gordon Harris, Will Hoogstraate, Mary Horswell, Ted Kingan, Hans Lasson, Ruth Maccormac, Kate MacSorley, Conroy Maddox, Gilbert Manley, Aubrey Manning, Peter Marsh, Tom Maschler, Oscar Mellor, Barbara Mercer, Christopher Moran, Michael Morey, David Morgenstern, Biddy Morris, Marjorie Morris, Ramona Morris, Philip Oakes, Helen Profumo, Gavin Rankin, Hans Redmann, Michel Remy, George Riches, Gordon Roberton, Michael Rodgers, Roger Sears, H. Slewe, Paul Stooshnoff, Jim Tazewell, John Treherne, Gerard Turner, Helen Turner, James Vaughn Jnr, Richard Veen, Ian Walker, Wylma Wayne and Paul Weir. A debt of gratitude is owed to each of them.

**Photographic credits** The majority of the paintings were photographed by Gordon Roberton of A. C. Cooper Ltd. Others were photographed by Michael Dudley (Figs. 71 and 108) and Oscar Mellor (Fig. 28). Fig. 44 was supplied by the Courtauld Institute of Art; Fig 88 was supplied by Longman Group Ltd. The photographers of the early studio portraits are unknown, but later ones were taken by Lutfi Ozkok (Fig. 118); Nancy Durrell-McKenna (Fig. 119); Jennifer Beeston, for the *Sunday Telegraph* (Fig. 2 and back of dust jacket; © *Daily Telegraph* Colour Library). The photographs of Desmond Morris with Joan Miro (Figs. 116 and 117) were taken by Lee Miller.

Phaidon Press Limited, Littlegate House, St. Ebbe's Street, Oxford OX1 1SQ

First published 1987
© 1987 Phaidon Press Limited

British Library Cataloguing in Publication Data

Morris, Desmond
    The secret surrealist : the paintings of
    Desmond Morris.
    1. Morris, Desmond
    I. Title
    759.2    ND497.M8/

    ISBN 0-7148-2448-8    172093-1001

Printed in Great Britain

*Frontispiece* **The Well-groomed Bride**, 1973. Oil on canvas, 22 × 16 in.

# List of contents

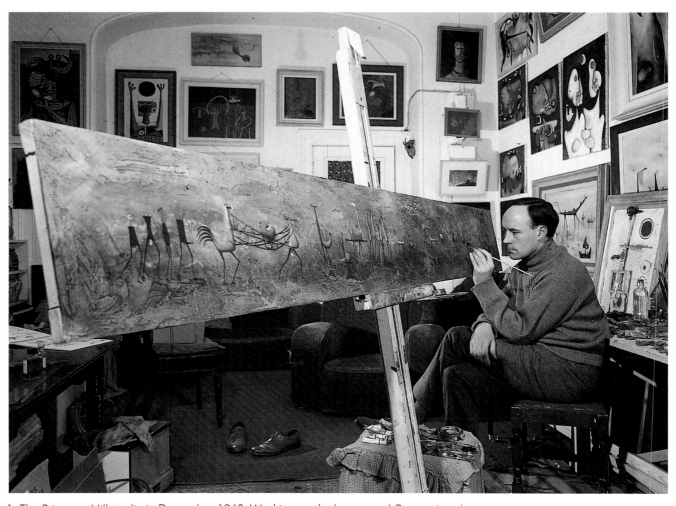

1 The Primrose Hill studio in December 1960. Working on the long panel *Processional*.

# Introduction

I first met Desmond Morris in the late 1950s when I joined the Granada TV–Zoological Society Film Unit at London Zoo as the script-writer for a series of films on animal behaviour. Desmond was head of the Unit. What we attempted to do was simultaneously inform and enchant – an admirable objective, but one which presents problems to programme-makers with planning schedules to meet.

We became a band of animal watchers, alert to the significance of the droop of a tail or the flick of a fin. We learned to resist the easy anthropomorphic rendering of what we saw. Animal behaviour, advised Desmond, could not and should not be explained in terms of human behaviour. We should not ascribe human motives to what animals did. To fall into that trap was to fall into error. Our job was to witness and record. Understanding, if we had fulfilled the first part of the contract, came next.

Years later it occurred to me that the same rules could be applied to both the making and the appreciation of art. I don't know if Desmond Morris invented the notion or even if he believes in its wider application (he is not, after all, a representational painter). There is, however, a precision about his images and a sense of their continuing history which gives them the status of characters in a saga which he has gradually revealed by painting, or telling it to himself over the years.

Significantly he has described himself as an 'explorer' and, although the label is a handy one to cover his many activities as a painter/zoologist/author/researcher, it is also quite literally true. His paintings are records of field trips, expeditions into the interior. What he finds in his imagination he brings back alive.

He calls the creatures which populate his canvases 'biomorphs', because they are 'biological in concept, but not representing a specific animal'. 'If it is possible to relate one of my biomorphs to a specific animal in real life I consider I have failed', he wrote once. They have lobes, spines, protuberances. Some of them strut with fleshy spurs; others have tufts of what looks like pubic hair. In settings which are usually sere or clinical they engage in furious debate, look quirky, fall in love or make war. They undoubtedly possess a strain of dark humour. Their encounters are invariably strange, but their behaviour and their postures are curiously reminiscent of our own. Why should this be? No kinship is claimed, but on another level – memory perhaps, some imprint of gesture, stylized and frozen like a dancer on an urn – we detect something of ourselves.

Desmond Morris traced their genealogy in his notes to the catalogue for an exhibition held in 1974 (Stooshnoff Fine Art):

Except when illustrating scientific publications I was never interested in depicting the external world, but while studying animal forms, I was inevitably

influenced by biological shapes and structures, colours and patterns .... I started to evolve a world of private creatures of my own. They mutate from canvas to canvas, growing, developing, changing. Some sort of general biological principles seem to be operating which guide me, but the results have nothing to do with the specific fauna of the outside world. The goal is to invent a new fauna and to nurse it through a slow evolution of its own, from picture to picture.

It has been a long process. Desmond Morris was born in 1928 and attended Dauntsey's School in Wiltshire where he edited a natural history magazine with H.G. Wells's grandson and debated whether he should become a painter or a zoologist. He began painting while still at school, but it was not until 1947, during his National Service in which he served as a Lecturer in Fine Arts with the Army Education Corps (one of two in the entire British army), that he produced his first 'biomorphic' picture. He held his first exhibition at the Swindon Arts Centre in January 1948 and later that year enrolled as a zoology student at Birmingham University where he took a first-class honours degree. In 1950 he shared his first London exhibition with Joan Miro at the London Gallery – at the time, he recalls, he was the youngest member of the British Surrealist Group – and in the same year he wrote and directed two Surrealist films, *Time Flower* and *The Butterfly and the Pin*.

He was, he admits, neurotically productive. During his spell at London Zoo he began an experiment with a chimpanzee named Congo into what he described in a subsequent book as 'the biology of art'. The starting point was the proposition (first advanced in an American psychology journal) that drawings by apes suggested the existence in the chimp brain of the basic elements of composition: the origin of human art itself. Over a period of years Congo produced 400 drawings which indicated, said Morris, 'that he carried in him, however primitive, the germ of visual patterning'. Keeping pace with his protégé, Morris himself painted 350 pictures during his time at the Zoo.

Many of these were produced in a studio looking out on Primrose Hill (Fig. 1) which we shared until developers demolished the house. It was a tall, shabby building with high ceilings and a steep marble staircase which wound up into darkness shared with only one other tenant. Gangs of youths occasionally fought running battles in the street outside. Desmond painted at night by electric light. Emerging early one morning he found the bonnet of his white sports car spattered with blood, as if someone had flicked it with a wet paintbrush. Further up the road a shopkeeper who came to his door to try and prevent a brawl was stabbed to death. Despite Desmond's insistence that the paintings are unrelated to the outside world, those that he produced during the early 1960s remind me powerfully of the tensions and the violence that boiled over our own doorstep.

The biomorphs vanished for a while and were replaced by austere black and white forms, almost abstract in their reduction to simple shapes but far from geometric in their patterning. They are composed but watchful: a background to action which is not of their making. Gradually brighter colours returned. The

pictures became bigger, the forms more genial, but there is no suggestion of the intense life conducted by earlier generations of biomorphs.

There is, I would suggest, a strong element of autobiography in all Surrealist art, available and recognizable because it draws without inhibition on the unconscious. A biomorphic episode or adventure may relate — fleetingly perhaps, or in part — to a common experience and there is a temptation to 'read' the paintings like panels in a comic strip. If one has personal knowledge of the artist, it is also tempting to ascribe particular paintings to periods in his or her life to demonstrate how they illustrate a passing mood or events of the day. The biomorphic paintings are not so specific. They are, in no sense, a diary. But I would have thought it natural, indeed inevitable, for them to reflect circumstances, good or bad, so that with hindsight one can construe the temper of the time in which they were painted.

In 1967 while he was, for a brief period, Director of the Institute of Contemporary Arts, Desmond Morris published *The Naked Ape* and left England the following year to live in Malta. For the first time in his working life he was rid of the constraints of office. He had no desk-work to tie him down, no committees to attend, no memos to write. He lived in a villa with a swimming-pool, an orange-grove and unlimited sunlight and for the next five years he produced paintings which are joyfully of that time and place. The colours are luminous. The mood is carefree. They are the work of a liberated man.

Morris returned to England in 1973 but, thirteen years on, his paintings still celebrate that emancipation. His biomorphs thrive. Their society seems to prosper, although its tensions and anxieties keep pace with our own. What he has created is a parallel world (one which he has also explored in his fantasy novel *Inrock*), and his documentation of its inhabitants and their customs is myth-making on a grand scale. It is also, without doubt, a commentary on our own situation. The scientist and the artist are the same man and they speak with the same voice. 'I never thought of myself as a zoologist who painted or as a painter who was interested in zoology', Morris once observed. 'They are both equally important to me because they both involve visual exploration'. The importance is undiminished. The exploration goes on.

London, October 1986                                                    Philip Oakes

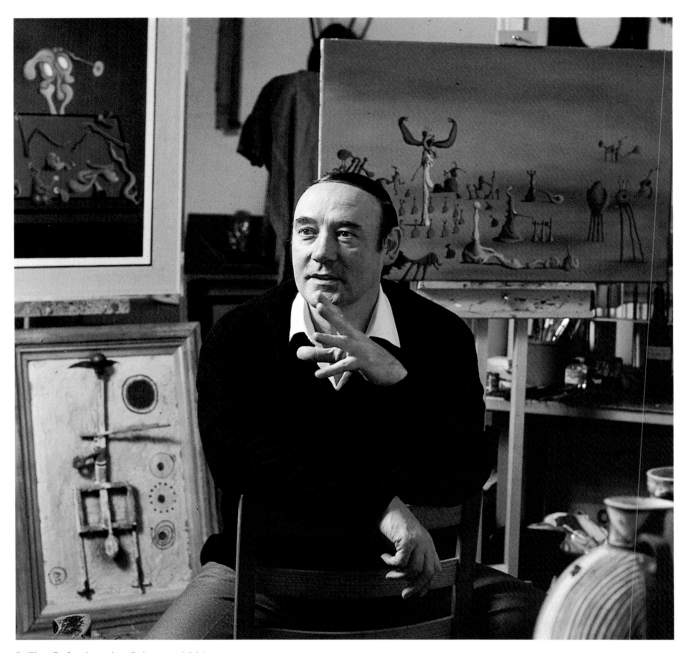

2  The Oxford studio, February 1986.

# The private painter

There was no tradition of art in my family. Words, not pictures, were the dominant theme. My father was a writer, my grandfather ran a newspaper, my great grandfather founded the newspaper, and my great great grandfather was a bookseller. So it was not surprising that I ended up earning my living as an author. What was surprising was that throughout my career I was, inside my head, obsessed with the challenge of painting pictures.

The elevated position of art in my scale of human priorities was due largely to a shy childhood in which visual impressions made the greatest impact. My family owned a lake where I could steal away to relish that special reward of being an only child – complete solitude. I built a raft and drifted silently over the surface of the lake. Lying flat on my belly I peered down at the strange underwater growths. Others wanted to catch fish; I wanted only to watch them. No matter how long I spent on my own, I never felt lonely.

One afternoon, nosing through the rushes at one side of the lake, I glimpsed a rounded, white and yellow shape floating just below the surface of the water. I prodded it with the blade of my paddle and immediately it disintegrated, swirling out among the weeds like thick cream dropped into coffee. It was probably only the carcass of a dead water-fowl, but it seemed to have no feathers and in my imagination it became a dead baby cast in the water by a forlorn young mother. The sinister image invaded my memory and locked itself there. In my private world there were many such images. With nobody to talk to, my eyes were working overtime.

Although cheerful enough and outwardly a very normal boy, inwardly I was developing a fine sense of the bizarre and the macabre. It became a burning ambition to see a horror film at the local cinema, but I was too young. Eventually I plucked up courage and marched boldly up to the box-office, only to be turned away with a stinging sarcasm. I resolved to take my revenge and persuaded a school-friend, whose father was an undertaker, to allow me to pay an unofficial visit to their mortuary. Even now, over forty years later, I can recall every detail of what I saw there. I cannot remember a single word that passed between my friend and myself, but the visual images have never left me. As it was wartime, the staff were overworked. It was late and they had all left for the day. There were bodies everywhere, soldiers brought back from the battlefields to be embalmed before making their long, final journeys home. Every slab was occupied. Some of the bodies were so badly damaged that they had to be embalmed one half at a time. In one case, the blood on only the left side of the body had been replaced by formalin, and the corpse had a marvellous, two-tone face, divided by a sharp line right down the middle of the nose, pale blue on the left, grey-pink on the right. Before I left I made a surprising discovery: with all the blood washed away, the shiny organs inside the human body had a strange, voluptuous beauty of their own. I would remember them . . . .

I mention these isolated events from childhood because they left a mark on me. No matter how joyous and pleasure-filled the child-years may be – and mine were certainly that – it is not the happiness that leaves the sharpest, most acute memories. The good times are not forgotten, of course, but they go slightly out of focus with the passage of time. The shock moments stay crystal clear. They are the only true ghosts in the universe, and they come back time and again to haunt us.

How vivid they are. It is late summer and I am twelve. The War is nearly one year old and we are enjoying a quiet picnic in a field near the river. We are eating large, red strawberries. Two twin-engined planes drone towards us in the sky. Lazily, almost in slow motion, they move close together. Their wing-tips touch and they fall steeply towards us, crashing into the field, one to the left of our picnic spread and one to the right. My father runs to help, peers inside the wreckage, then walks slowly across to a hedge and vomits. He has been ill for some time. The strawberries have suddenly become obscene . . . .

I am fourteen and I have watched my father die very slowly, his health ruined in the trenches of the First World War. All through my childhood he has been suffering with restraint and a stubborn dignity. Now that he has succumbed I am strangely quiet. Like him, no fuss. But inside there are raging furies. My bereavement takes the form of an impotent anger, a hatred of the authorities who have caused him to die so young. It is the start of a lifelong distrust of priests and politicians – the priests because they seem to be excusing the horrors of this life by the phoney offer of a glorious after-life, and the politicians because it is they who send young men like my father off to war while they themselves stay snug in their headquarters. With juvenile clarity I see them for what they are: gobbledegook conmen and cowardly hypocrites. But I remain silent. Their secret is safe with me. I have other things on my mind . . . .

I have decided to construct a private world of my own. As yet I do not know how to go about it but I am impatient because, since I do not expect to live too long, I want time to enjoy it. In practice this means spending more and more time on the family lake in the company of the birds and the fish there. I am becoming increasingly absorbed with their colours and their movements. But this is not enough. Finding my great grandfather's brass microscope in an attic I plunge into an exciting new world of microscopic organisms. I think my left eye will go blind staring down that magic tube hour after hour. If only I could miniaturize myself and explore.

At school, inevitably, I become a zoologist. I find I can think like the species I am studying, whatever it is. If I am watching a lizard, I become a lizard. Gazing down through the water at a pike, I become a pike. No danger for me of anthropomorphizing. Just the opposite. As for the human species, it fills me with disgust. In a school essay written when I am sixteen, I describe human beings as monkeys 'with a diseased and festering cranium'. (It will take me more than twenty years to get to like my species enough to elevate it to the level of my much-loved animals and to rechristen it with the more noble title of 'The Naked Ape'.) In public, however, I remain the quiet, polite boy I was brought up to be. It is not the individuals I *know* that I despise. Like anyone else I have close

friends and cherished loved ones. It is just the human species as a whole that I find so disgraceful. And the Second World War which is raging around my childhood does little to improve my view of humanity.

Much as I love my animals, they fail to satisfy completely my need to construct a private world of my own. Something more is required. The solution to the problem arrives from an unexpected source. I am browsing in the school library and come across a volume of etchings by Goya called *The Disasters of War*. The human cruelty they depict makes a violent impact on me, for two reasons. First, it confirms my darkest suspicions about my species; second, it makes me realize for the first time in my life that mere pictures on a flat surface can be deeply moving. It is a moment of true conversion: from art-philistine to art-fanatic. Previously I had thought of art as effete nonsense akin to flower-arranging and embroidery. I had found the safe, traditional art I had encountered as boring as religion and as tedious as politics. I had never entered an art gallery and had no desire to do so. But Goya is something else. He shows me that pictures can have great power. The act of picture-making suddenly commands a new respect.

This discovery takes place when I am sixteen and within a few months I am already busily making sketches. At the time I make no conscious connection in my mind between the impact of Goya and the start of my own picture-making. But the link is glaringly obvious. Naturally, my first sketches are not of the safely traditional type. From the very beginning they are intensely personal and subjective, depicting strange shapes largely influenced by my biological studies. I am already starting to 'grow' a private world of my own. I still have a fierce intolerance of all representational art and pour scorn on it at every opportunity with the fine arrogance of which only a teenager is capable. The scorn of my teachers upon seeing my early sketches is equal and opposite. They casually condemn my sketches as 'rubbish'. Without realizing it they are giving my new-found urge an enormous boost. For these men represent to me the tiresome face of tastefully decorative art and for them to hate my sketches can only mean one thing — I am on to something important.

By the age of seventeen, I have discovered the glorious medium of oil paint. At eighteen, I have become obsessed with the whole process of picture-making and already have a studio full of paintings. By nineteen, I have at last found the style I want, enabling me to escape into a secret, personal world peopled by curious biomorphs of my own invention. Of necessity, this style has to be meticulous and detailed, to make my invented world as real as possible. I am not interested in painterly strokes of the brush, only in the images I am forming.

On a scrap of paper I try to write down my feelings about these early paintings and the world they depict. My greatest desire is to jump through the frame of one of my pictures, like Alice through the Looking-glass, and disappear for ever into my surreal world. I express myself in the typically melodramatic words of a nineteen-year-old:

> ... but if I am to escape from reality on the raft of my imagination, what constitutes the planks and rope that go to build the raft? They come from your

world and I must have them before I can escape to mine. For mine is an existence within an existence, a personal place where I would go and shut myself up. Sometimes I feel the whole affair hopeless and I gaze through a clouded veil . . . . I am like a fly in a web, a kitten in a knotted sack. A short struggle, a glimpse of freedom, and the veil is back.

Despite these secret thoughts I am outwardly an average citizen, chasing girls, drinking beer and playing the approved social games. Only in my paintings does my haunted mind expose itself. I am still only nineteen when I hold my first One-man-show of pictures at a local art gallery. To my private satisfaction and my family's distress, the local newspaper is filled for day after day with angry letters to the Editor from outraged art-lovers. Every insult known to these art-lovers is hurled at my silent canvases. There is something revealing in the phrases they use: 'Nightmares masquerading as art' . . . 'Atrocities misnamed art' . . . (and most delightful of all) . . . 'Framed fanatical monstrosities introduced to the public as art.' I notice the word 'art' cropping up again and again as if it is something sacred. This reaffirms my belief that traditional art belongs in the same category as formal religion. Both have clearly become authoritarian systems imposed on society as a set of meaningless rituals, devoid of curiosity and bereft of imagination. I now add 'art-lovers' to my Despised List, along with priests and politicians.

Greatly encouraged by the powerful emotions my early pictures have churned up, I step up my production. By the age of twenty two, I have completed a total of 328 paintings. Although I am still a student at university (pursuing my zoological career), I am already holding my first London exhibition and sharing it with one of my idols, the great Spanish artist, Joan Miro.

My juvenile enthusiasm is dampened somewhat by the financial failure of the exhibition. Several of the paintings are sold, but the money does not even cover the cost of the show. There is no way that I can make a living out of full-time painting unless I am prepared to make my pictures more 'tasteful' and commercial. This I will not do. The only alternative is to go underground – to continue to paint exactly the way I want to paint, but selfishly, for myself alone. I will become a private painter, earning my living as a scientist.

That is the decision I took, back in 1950, and that is the way it has been ever since. I have never stopped painting. I have continued, through canvas after canvas, to explore my private world of biomorphs and to nudge them gently along through a gradual evolution. That early urge of mine to jump through the frame and disappear into my personal landscape has never vanished, although I have it well under control. As the years have passed, I have come to terms with the human species and even grown rather fond of it. I have developed a tolerance of traditional art and found many rewards in it. The sharp, silent anger of my early days has been eroded. But once I am in my studio again, nothing has changed. I am transported one more time to my strange, personal world with its own unique rules, and linger there for a few more hours, watching the biomorphs take shape under my brush. I will never tire of it because I never know quite what will happen next.

I do not expect anyone else to share my interest in a world so intensely personal, but I am pleased if they do. In my writings I try hard to communicate with as many people as possible. In my paintings I do not try to communicate with anyone except myself. All other considerations are secondary. For art, as Herbert Read once said, is 'adult play'. The artist, therefore, must remain a mature child and, as such, may be forgiven the selfishness of childhood. It is only within that framework that he can allow his inventiveness full reign.

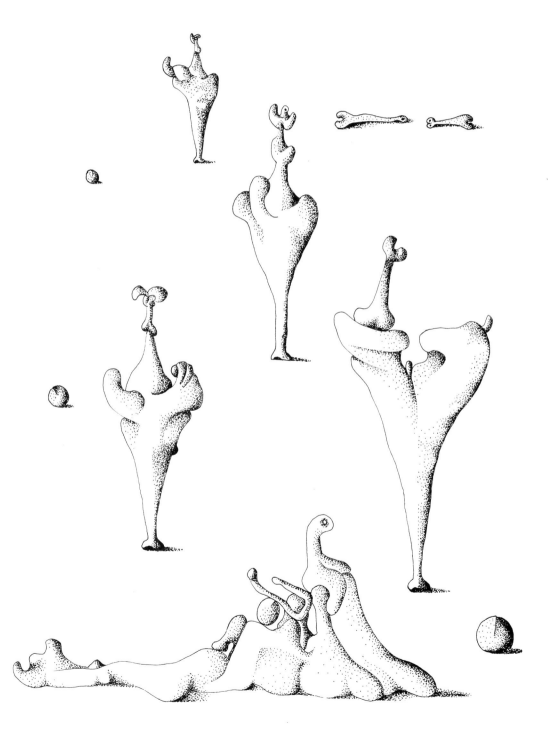

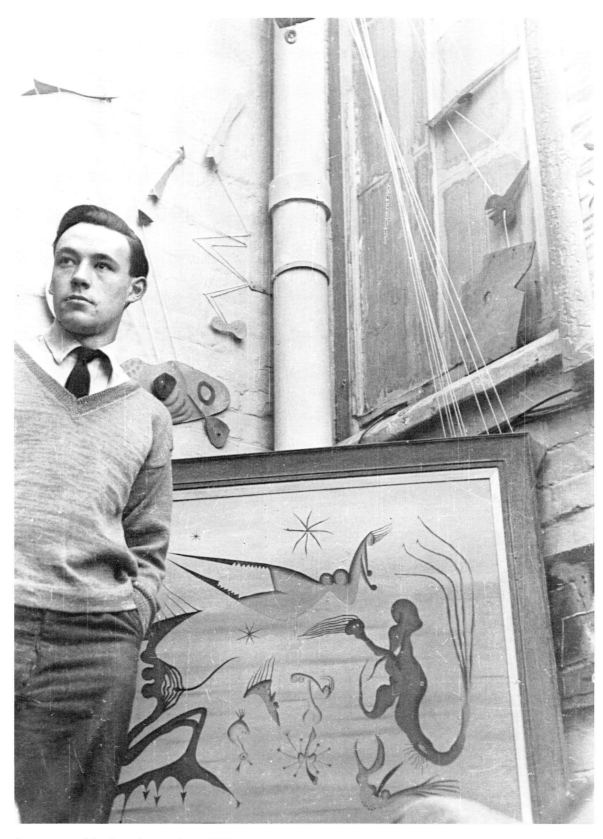

3  A corner of the Swindon studio in 1948.

# The paintings

The table of Surrealism stands on four legs. The first we may call the poetry of chance; the second the joy of exaggeration; the third the shock of juxtaposition; and the fourth the invention of images.

The first, which derives from the Dadaist precursor of Surrealism, is concerned with the excitement of introducing random elements into art. The second, which is shared with much tribal and ancient art, has to do with the intensification of familiar images by exaggerating some elements and suppressing others. On the human form, for example, the eyes may become huge, the head vast, while the arms and legs are reduced to mere stumps. This is the approach of which Miro is the master. The images in his paintings are all identifiable – women, men, birds, stars – but their impact is startling because of the way he has super-normalized some details and sub-normalized others. The third, by contrast, does not involve distortions of this kind, but concentrates instead on realistic portrayals of familiar objects. The surreal shock comes not from the individual images but from the unexpected way they are made to relate to one another. Masters of this genre, such as Magritte and Dali, present us with realistic forms in a surrealistic combination – Magritte's businessman with an apple in place of a head, Dali's elephants with spider's legs. The fourth accepts the difficult challenge of trying to create a new world of invented images – forms that no longer bear a one-to-one relationship with existing objects, but are evolved by the artist as original forms in a novel existence. The Surrealists most successful in following this course have been Tanguy, Matta and Arp.

It is this fourth approach that fascinates me most. Being a biologist and a student of evolution, I attempted to evolve my own world of biomorphic shapes, influenced by but not directly related to the flora and fauna of our planet. From canvas to canvas I have tried to let them grow and develop in a natural way, without ever crudely borrowing specific elements from known animals or plants. This process began as early as 1944, but it was not until 1947 that it gained confidence in itself. My early records show that, of the 150 paintings completed before 1947, 123 were destroyed. I was dissatisfied with the images and was still learning my craft. Then, in 1947, I completed a strange picture called *Entry to a Landscape*, which showed a narrow glimpse of a biomorphic world seen through a cleft in a dark rock-face. It was as though I had offered myself a route of access to a secret, inner personal world. In my mind's eye, I slipped through this crack in the rocks and there I was, suddenly surrounded by a whole array of bizarre inhabitants, all busy courting, fighting, breeding and moving about in front of my eyes. I no longer had to search for them, they were everywhere, making their own demands of me and establishing their own rules. With each new canvas they grew beneath my brush, as though I had become merely their observer rather than their creator. I watched them fondly as they developed and mutiplied from canvas to canvas, in my early biomorphic paintings.

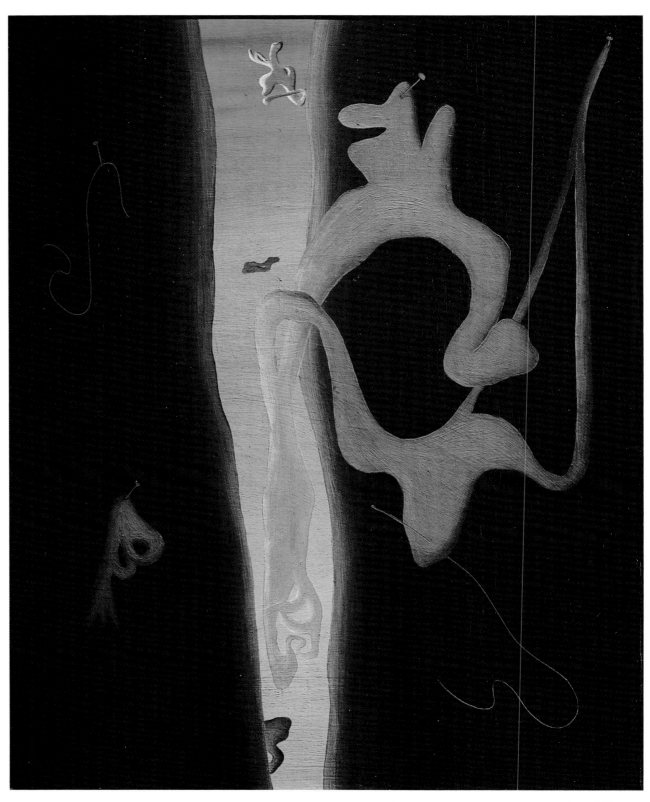

4 **Entry to a Landscape**, 1947. Oil on board, 20 × 16 in.

*Please note:* The titles of the paintings are unpremeditated. They are free-association labels attached to the pictures after completion for purposes of identification.

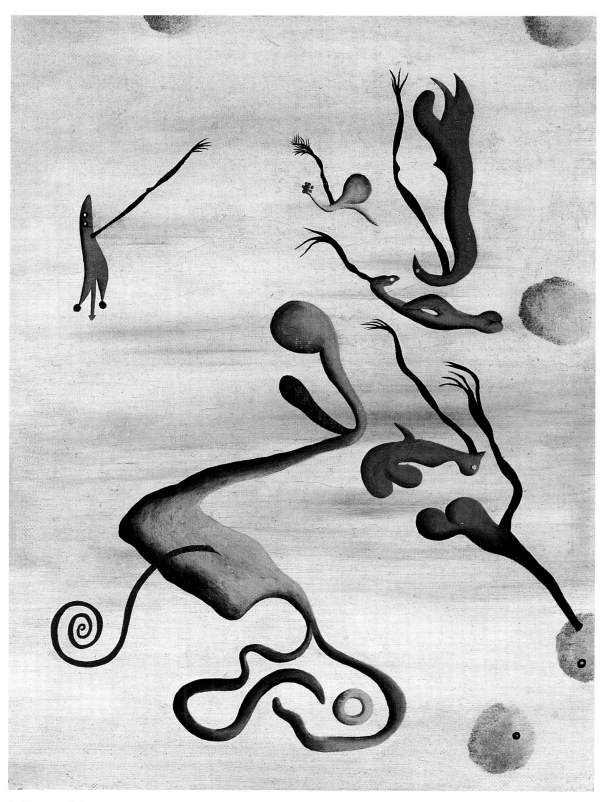

5 **Master of the Situation**, 1947. Oil on canvas, 16 × 12 in. Collection Mr Alasdair Fraser, London.

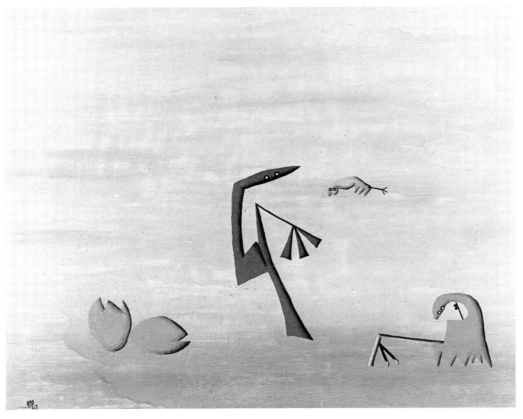

6 **The Nest I**, 1947.
Oil on board,
13 × 17 in. Collection
Professor Aubrey
Manning, Edinburgh.

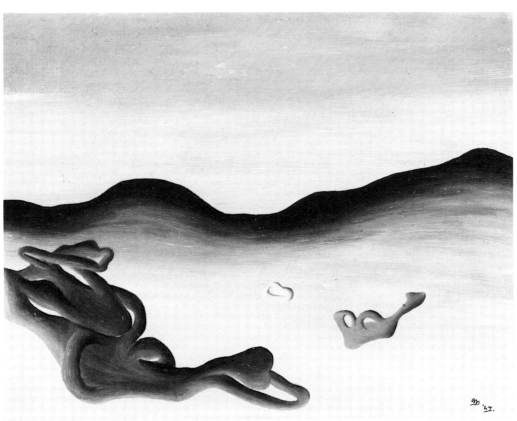

7 **Landscape for a
Para-introvert**, 1947.
Oil on card, 14 × 18 in.
Collection Mr Hugh
Clement, Wales.

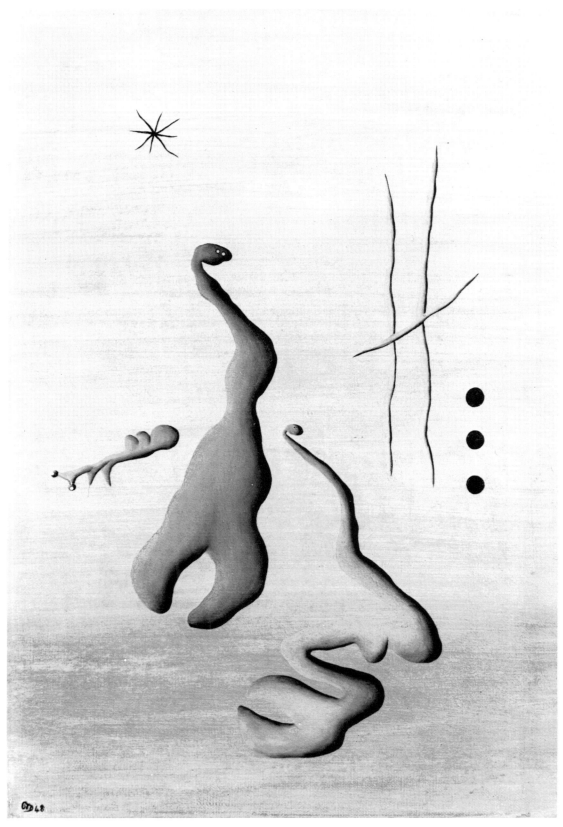

8 **Confrontation**, 1948. Oil on canvas, 18 × 12 in.

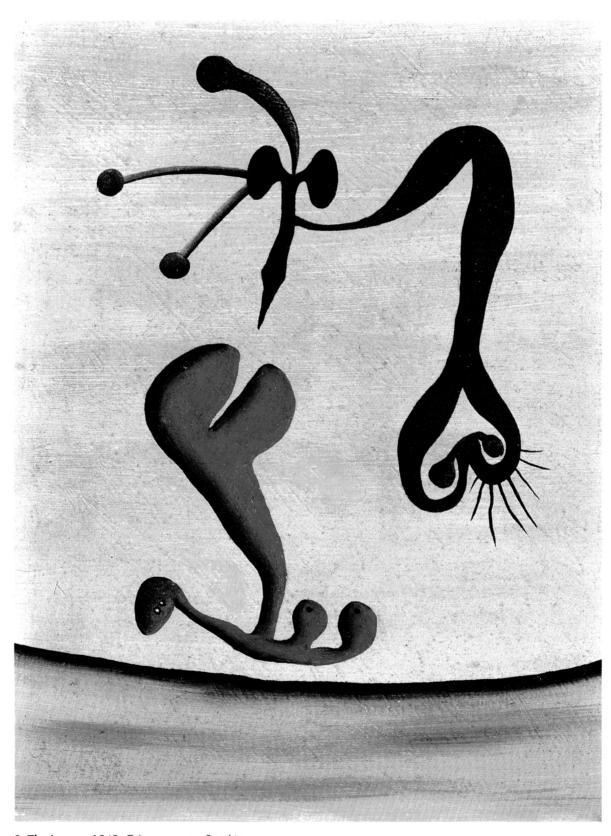

9 **The Lovers**, 1948. Oil on canvas, 8 × 6 in.

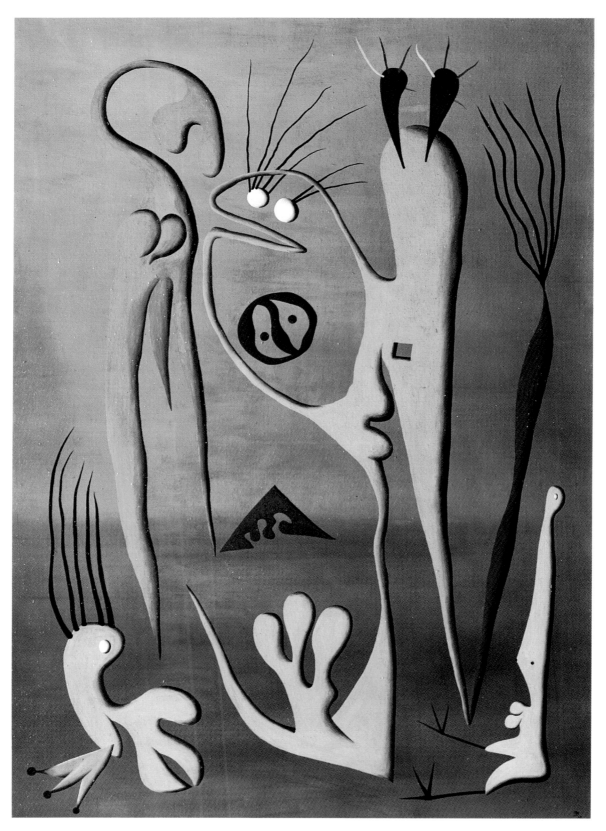

10 **The Courtship I**, 1948. Oil on canvas, 54 × 38 in.

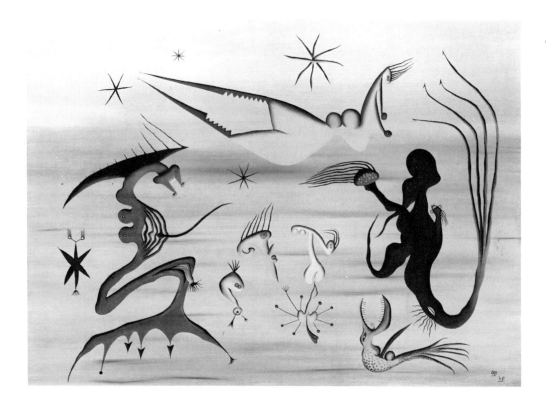

### The Swindon studio, 1945–1951

The year 1948 was the most productive of all, with eighty-nine paintings completed. Of these, fifty-three were later destroyed, but a glance at the survivors reveals that there were two distinct types. There were those that showed groups of biomorphs lying, standing or floating in a deserted, smooth-surfaced, empty landscape. As it turned out, this was going to prove to be the basic theme which would reappear from the forties right through to the eighties. From time to time, however, there were technical experiments — exploratory attempts to find new ways to present the biomorphs. In *The Close Friend* (Fig. 13), linear outlines were employed as 'image intensifiers'. I later learned that Miro had told an artist that each line in a painting should 'cut like a knife'. In *The Close Friend* this is literally what happened, the powerful lines cutting deep into the un-dry surface of the background paint. Although successful here, it was not a style that I pursued. Another technique, to which I did return occasionally, was the creation of a rough plaster surface on which to depict the biomorphs, as in *The Dove* (Fig. 14) and *The Hunter* (Fig. 15). This had the primitive appeal of working on a cave wall. Other ways of rendering the background more complex without developing it into a conventional landscape were tested, as in *The Table* (Fig. 16), *The Inhabitants* (Fig. 20), and *The Survivors* (Fig. 21). Sometimes the pendulum swung in the opposite direction, with everything, including the biomorphs themselves, portrayed in pure, flat colour, as in *The Intruder* (Fig. 17). And sometimes three-dimensional devices, using wood, rubber and cork, were employed to dramatize the biomorphs, as in *War-woman* (Fig. 19), although this was rare.

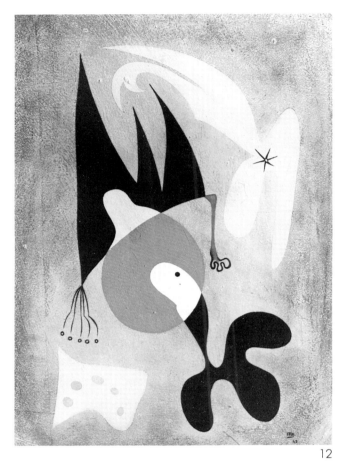

12

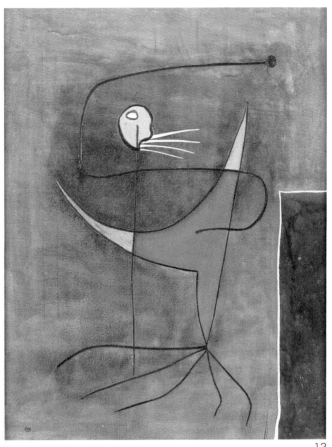

13

12 **The Red Dancer**, 1948
Oil and pastel on card,
18 × 13 in.

13 **The Close Friend**,
1948. Oil on canvas,
26 × 20 in. Collection
Dr John Treherne,
Downing College,
Cambridge.

14 **The Dove**, 1948. Oil
and plaster on canvas,
23 × 26 in.

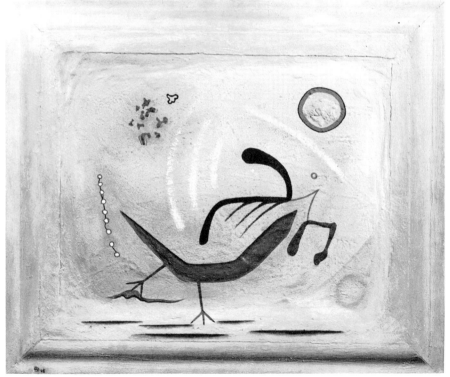

14

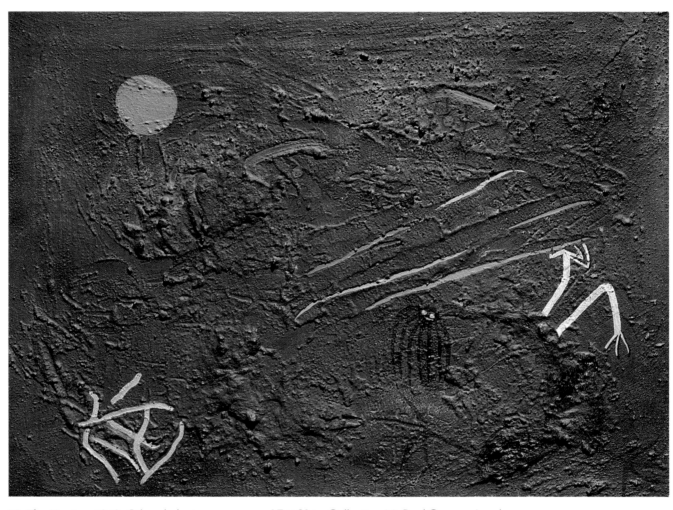

15 **The Hunter**, 1948. Oil and plaster on canvas, 17 × 21 in. Collection Mr Paul Conran, London.

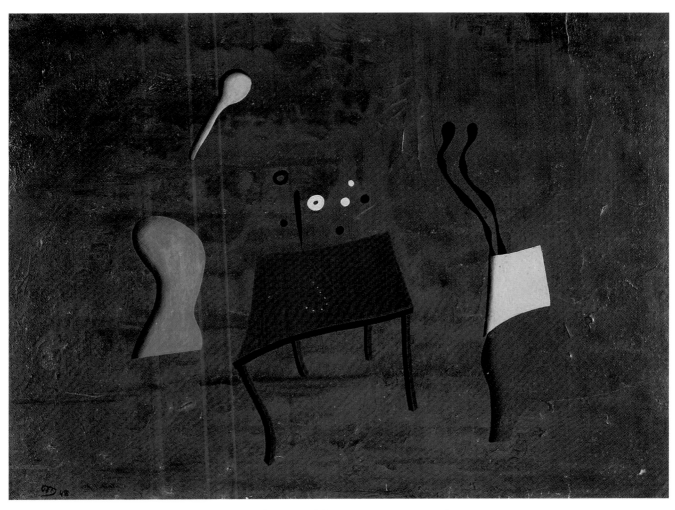

16 **The Table**, 1948. Oil on canvas, 14 × 18 in. Phipps and Company Fine Art, London.

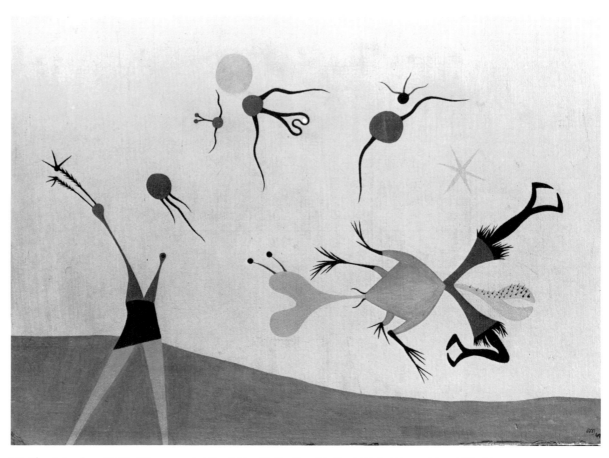

17 **The Intruder**, 1949. Oil on card, 12 × 16 in. Collection Mr Paul Weir, Wroughton, Wiltshire.

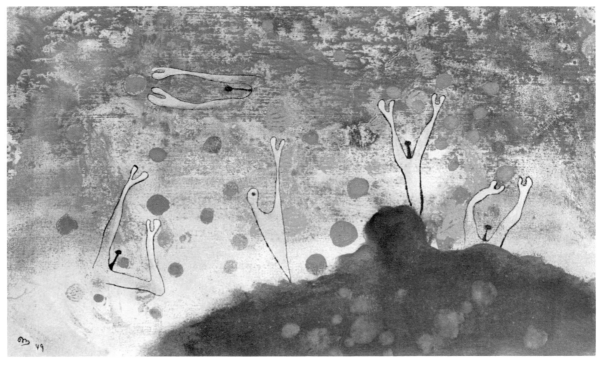

18 **The Apple-pickers**, 1949. Oil and indian ink on paper, 8 × 13 in. Collection Mr Philip Oakes, London.

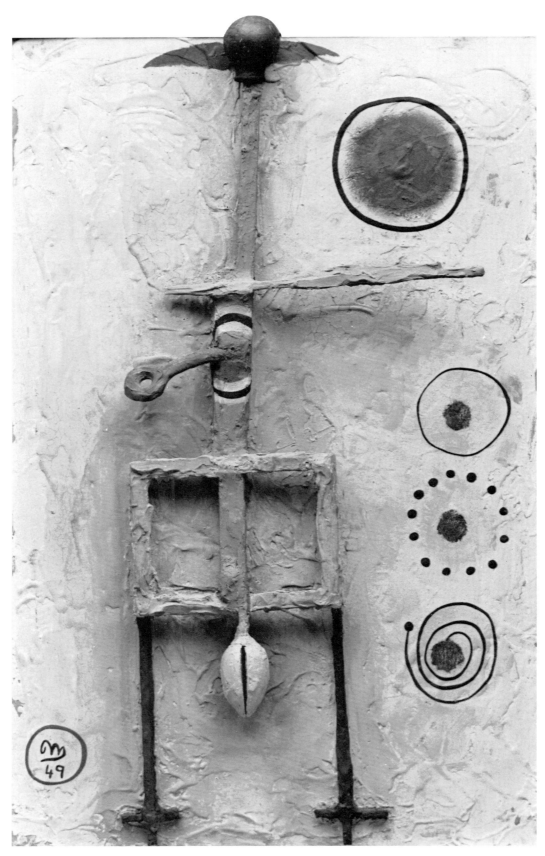

19 **War-woman**, 1949. Mixed media on board, 28 × 17 in.

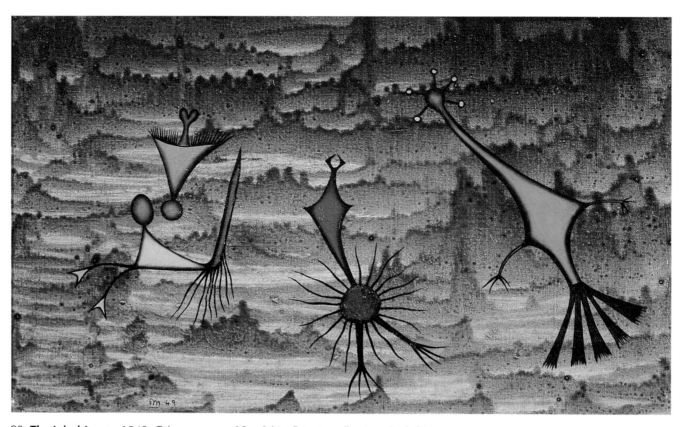

20 **The Inhabitants**, 1949. Oil on canvas, 10 × 16 in. Private collection, Berkshire.

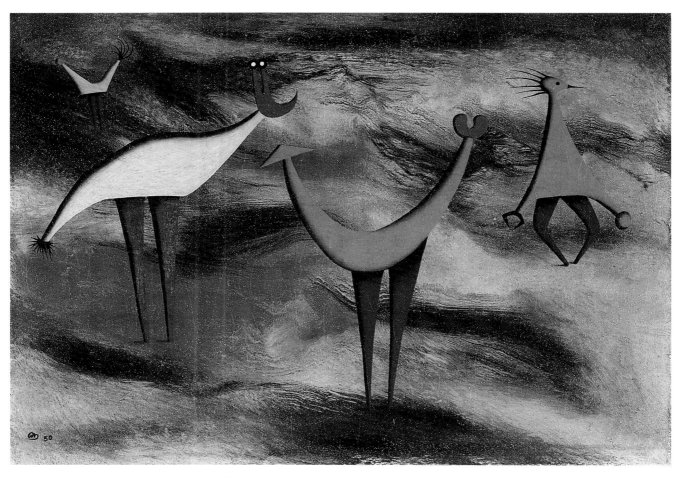

21 **The Survivors**, 1950. Oil on canvas, 10 × 14 in.

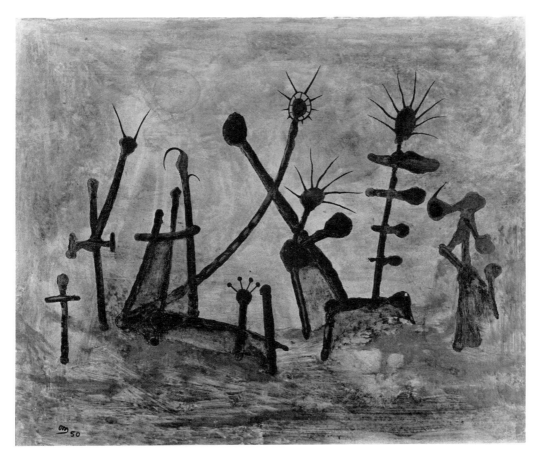

22 **Blue Landscape**,
1950. Oil on board,
12 × 14 in. Collection
Professor Aubrey
Manning, Edinburgh.

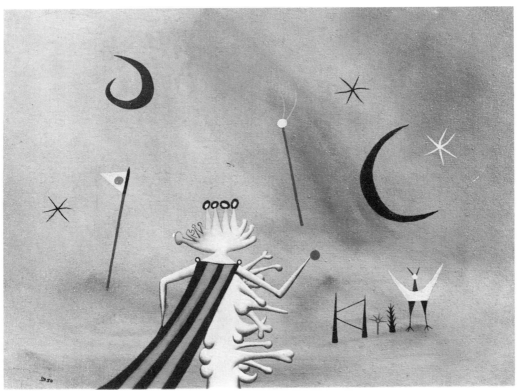

23 **The Progenitor**,
1950. Oil on canvas,
12 × 16 in.

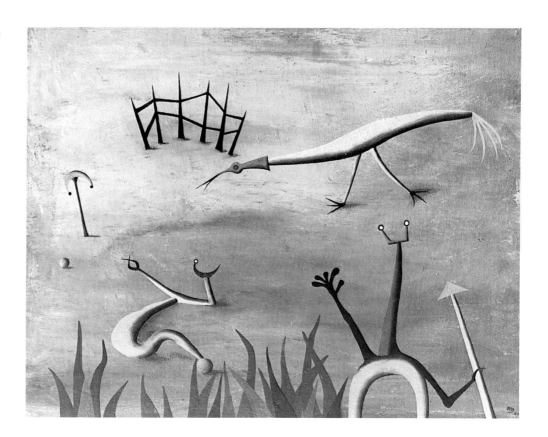

24 **The Trap**, 1950. Oil on canvas, 16 × 20 in. Collection Mr Tom Maschler, London.

25 **Endogenous Activities**, 1950. Oil on canvas, 21 × 31 in. Collection Mrs Mary Horswell, Windsor.

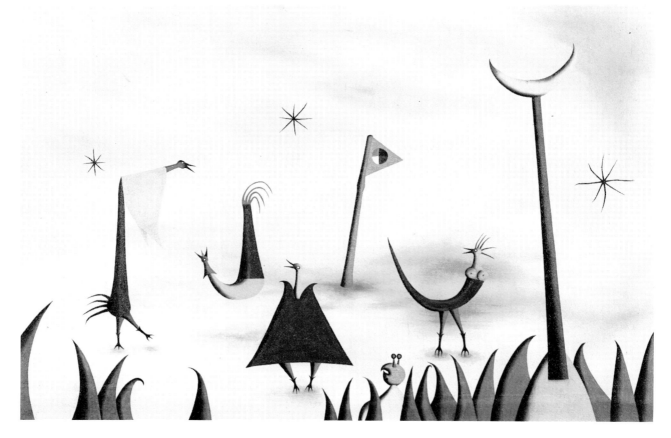

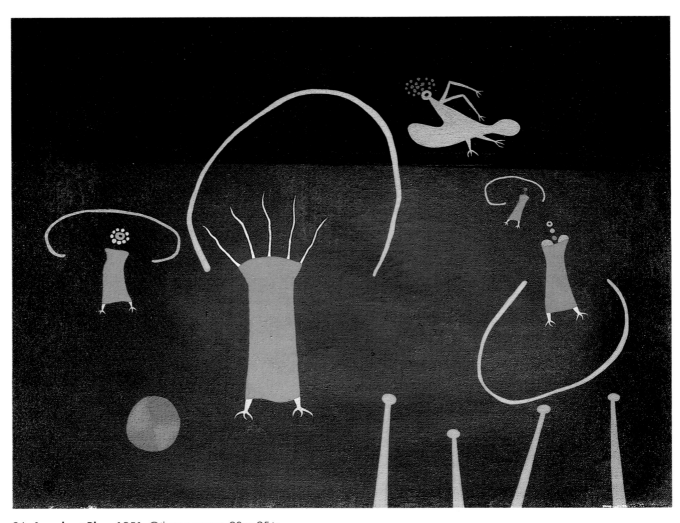

26 **Angels at Play**, 1951. Oil on canvas, 20 × 25 in.

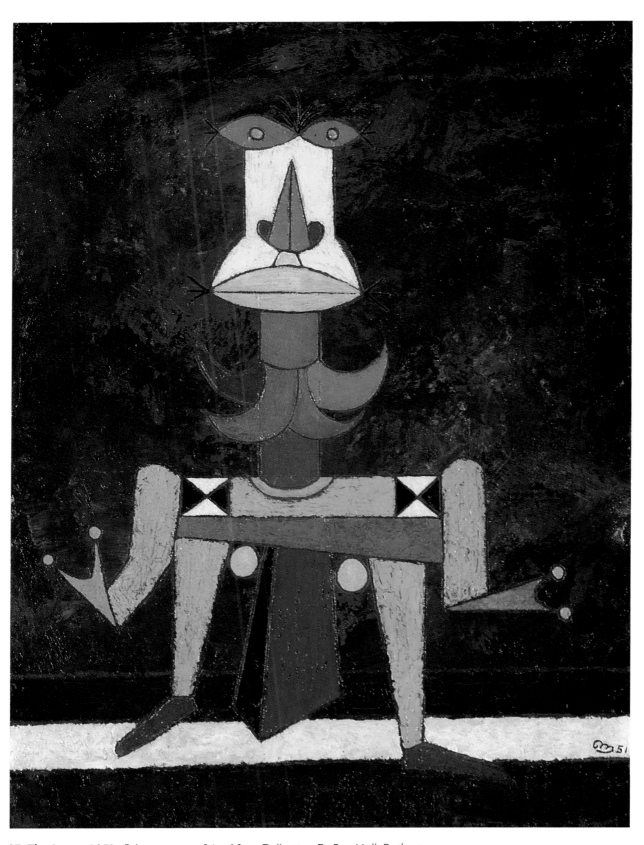

27 **The Jester**, 1951. Oil on canvas, 24 × 18 in. Collection Dr Fae Hall, Bath.

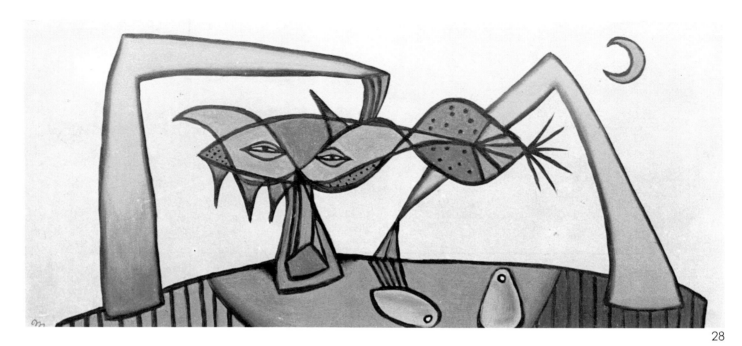

28

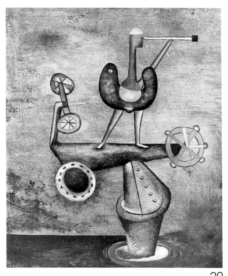

29

28 **Woman Thinking to Herself**, 1951.
Oil on board, 12 × 24 in. Collection
Mr Oscar Mellor, Exeter.

29 **The Scientist**, 1952. Oil on board,
13 × 10 in.

30 **The Comforter**, 1952. Oil on board,
32 × 26 in. Private collection, Devon.

30

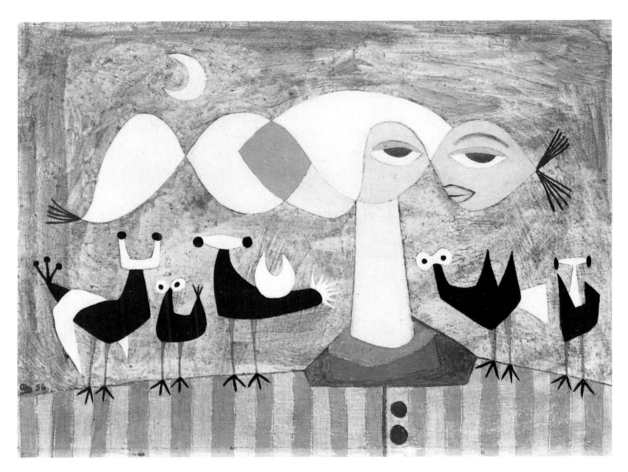

31 **Woman with Birds**, 1956. Oil on canvas, 9 × 12 in. Collection Mrs Ramona Morris, Oxford.

## The first Oxford studio, 1951–1956

Few of the paintings from the Oxford research years of 1951–6 have survived. Each time I moved house and set up a new studio, I cleared out the old one, destroying most of the paintings or giving them to friends. Although I now regret the mass destruction of early pictures, at the time it had a valuable cleansing effect, purging me of the burden of the old work and enabling me to start out on new work with greater vigour, almost as if I were trying to replace the lost pictures.

## The London apartment, 1956–1960

Arriving in London in 1956, I found myself for the first time without a studio in which to paint. Living in a small apartment in Regent's Park, I was reduced to working on a much smaller scale than usual. I purchased a stack of thirty-six tiny 7 × 14 in. canvases, small enough for me to paint while sitting at a desk in my bedroom. Between 1956 and 1958 I completed all of these, but could do little else because of the cramped space. Two examples are included here, *The Spanish Table* (Fig. 32), and *The Enclosure* (Fig. 33). In 1959 painting almost came to a halt. One of the few pictures completed was the small canvas called *The Revolt of the Pets* (Fig. 34), which reflected my new appointment as a Zoo Curator. The visual impact of my new post was such that it impinged with unusual strength on the private, personal world of my biomorphs.

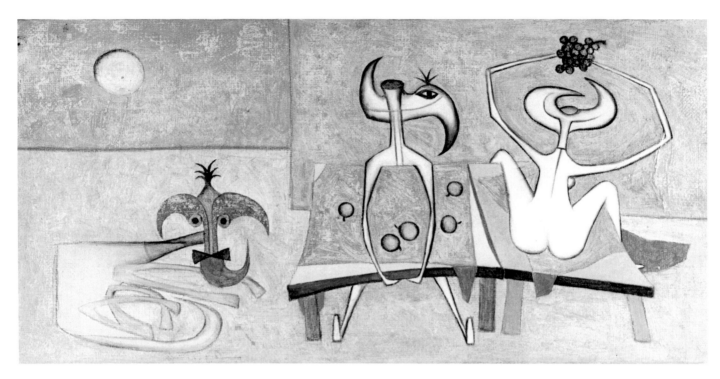

32 **The Spanish Table**, 1957. Oil on canvas, 7 × 14 in. Collection Dr Gilbert Manley, Durham.

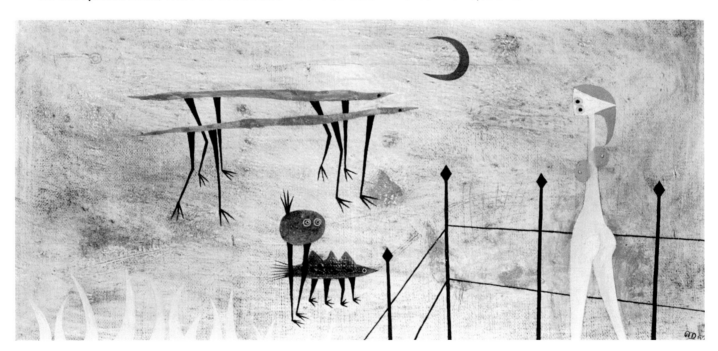

33 **The Enclosure**, 1957. Oil on canvas, 7 × 14 in.

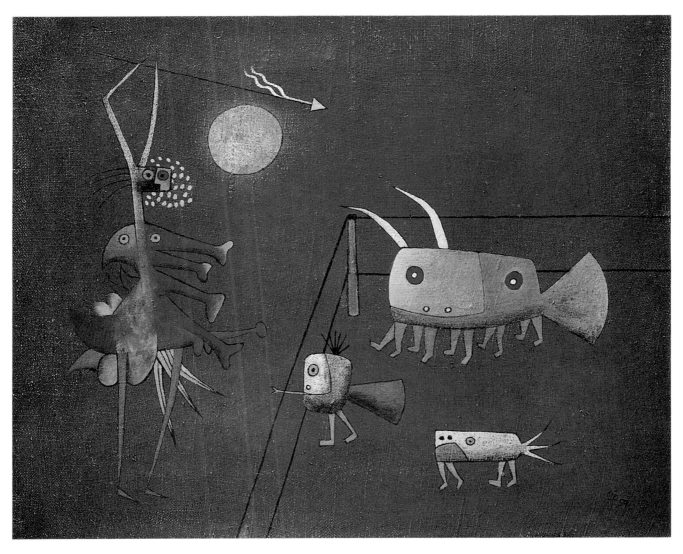

34  **The Revolt of the Pets**, 1959. Oil on canvas, 10 × 12 in.

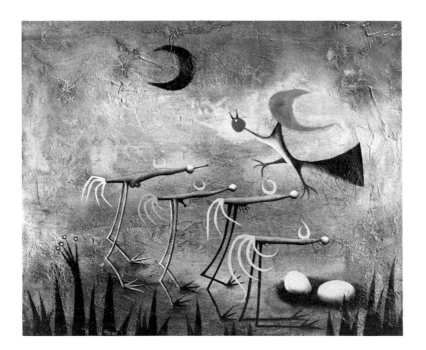

35 **The Egg-thieves**, 1960.
Oil and plaster on canvas,
14 × 17 in. Collection Mr
Tom Maschler, London.

## The Primrose Hill studio, 1960–1965

In 1960, by a stroke of luck, a large studio became available overlooking Primrose Hill, near Regent's Park. It had become free because the old building in which it existed was due to be demolished in a few years time. The great, tall room gave me more space than I had ever enjoyed before and I set to work on huge paintings as much as seven and even eight feet in length (as in Fig. 1). After a long period of working in cramped conditions, however, I was not immediately able to enlarge my images. As a result, the new big canvases were populated with a throng of tiny, spindly biomorphs of the type that had adapted themselves to the diminutive canvases of the past few years. The only innovation was a rough plaster surface to provide a more complex texture for the biomorphic environment (as seen here in a smaller canvas from this same period, *The Egg-thieves*, Fig. 35.)

By 1961, the large space of the new studio began to make its impact, and when this happened a dramatic change in the paintings took place. Gone were the scenes of small biomorphic creatures and in their place was a long series of rather sombre heads, two of which are included here (Figs 36, 37). It was as if I had changed the lens on my microscope, moving in close on the head regions of the biomorphs to the exclusion of all else. No-one who saw these oppressive 'portraits' liked them, including myself, but they refused to go away. Time after time they demanded to be painted and, with great perversity, they refused to display any recognizable facial expression. It was as if somehow in my life I had adopted a mask and my paintings were repeatedly reminding me of this fact, whether I liked it or not. I gradually emerged from this phase, via some strangely bleak white paintings, to explosively reproductive themes of fertilization and ovulation (Figs 39–41). The pressures of my increasingly public life as a television performer were clearly beginning to tell on me.

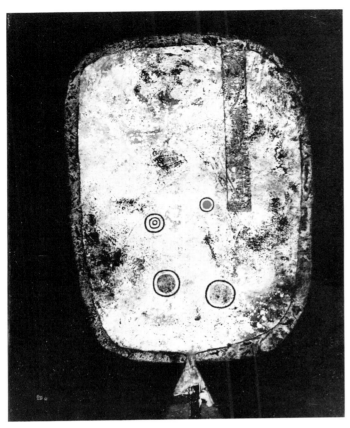

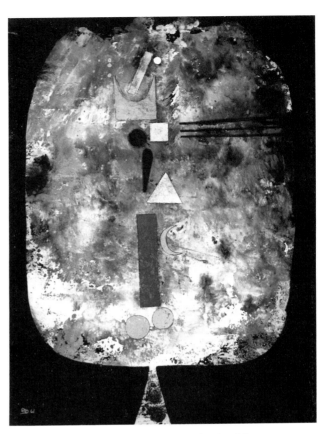

36 **Cell-head I**, 1961. Oil on card, 18 × 14 in.

37 **Cell-head VII**, 1961. Oil on card, 20 × 15 in.

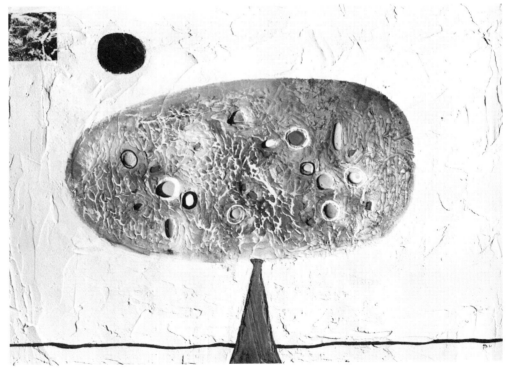

38 **Egghead I**, 1961. Oil and plaster on board, 18 × 24 in.

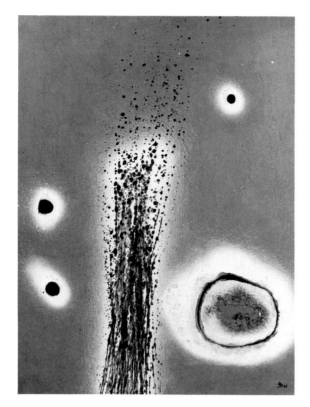

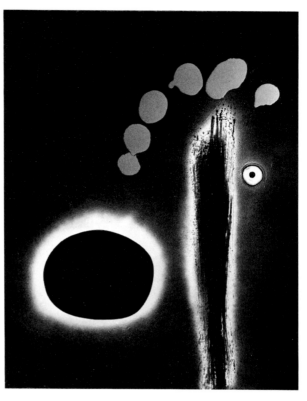

39 **Force of Fusion**, 1961. Oil on canvas, 16 × 12 in.

40 **Fertilization II**, 1961. Oil on board, 39 × 30 in.

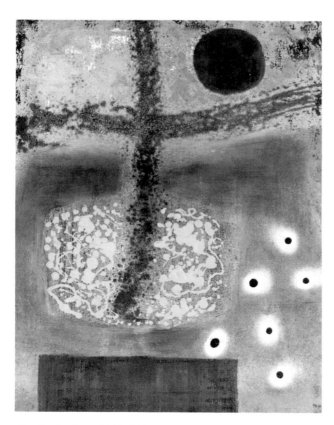

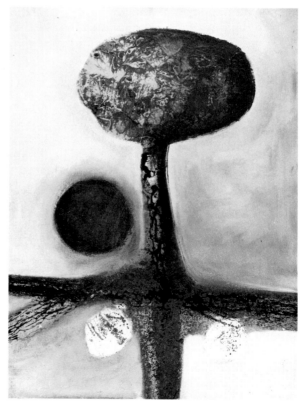

41 **Ovulation**, 1961. Oil on canvas, 29 × 22 in.

42 **The Addiction of Privacy**, 1961. Oil on canvas, 30 × 20 in.

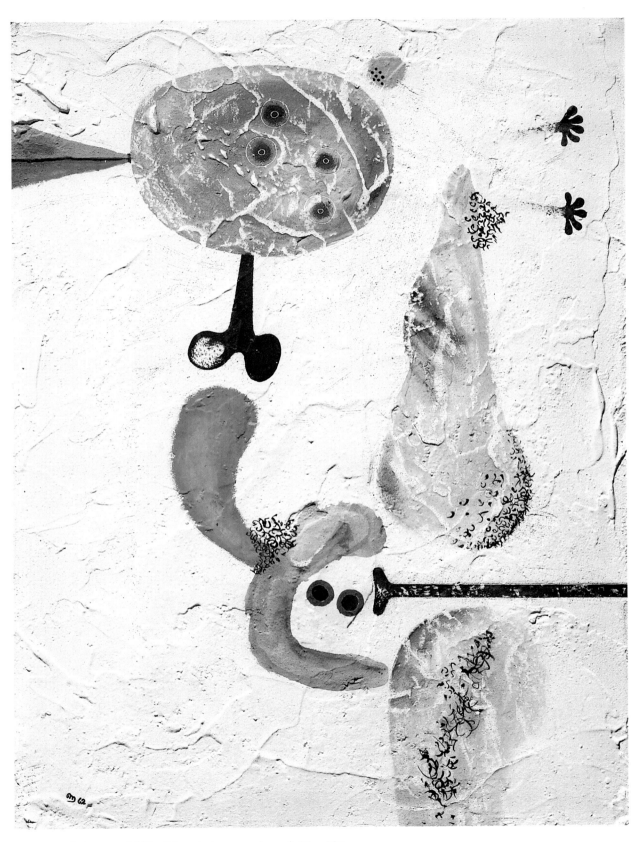

43 **Point of Contact**, 1962. Oil and plaster on board, 24 × 18 in.

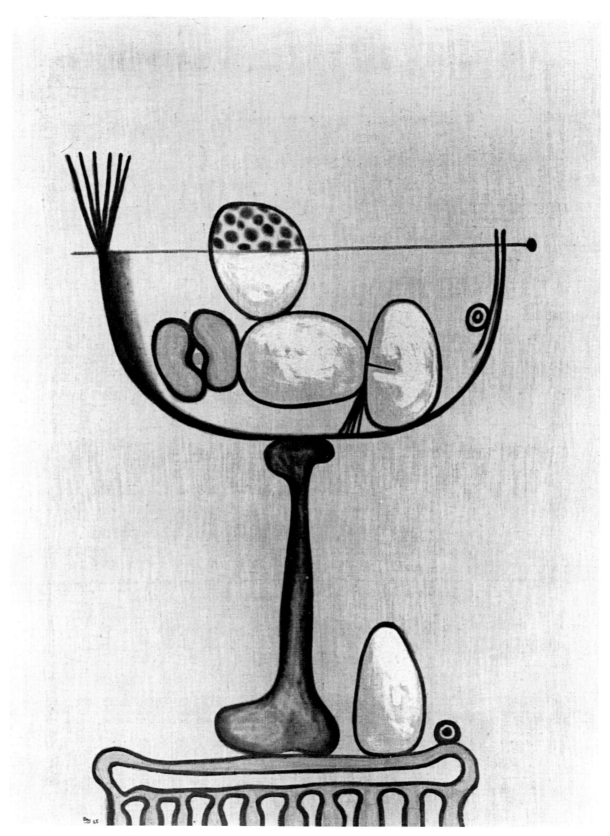

44  **The Mysterious Gift**, 1965. Oil on canvas, 39 × 28 in. Swindon Art Gallery.

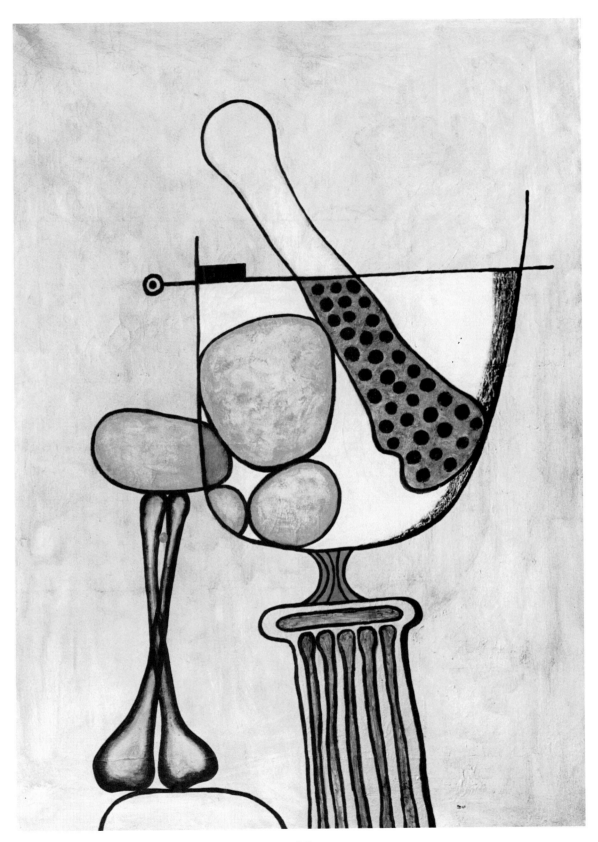

45 **Ambiguous Offering**, 1965. Oil on canvas, 54 × 37 in.

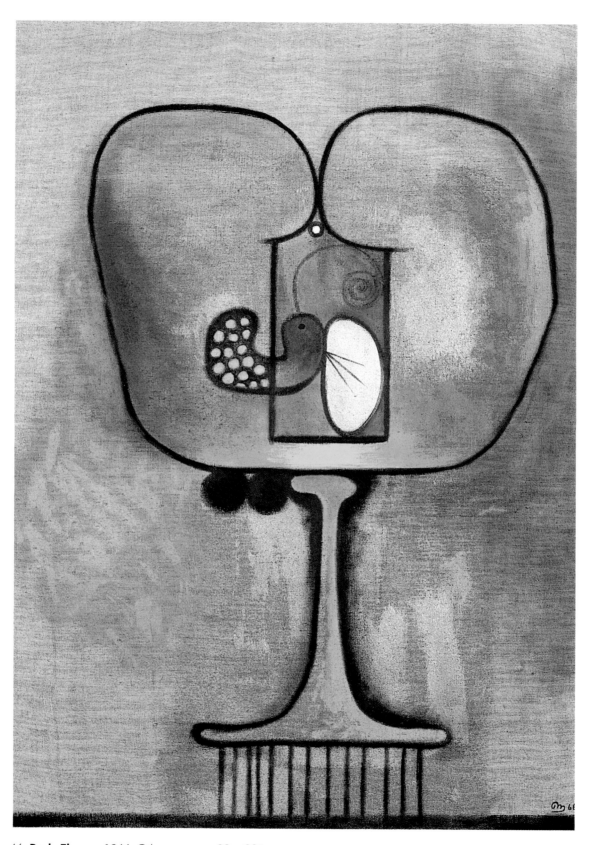

46 **Body Flower**, 1966. Oil on canvas, 33 × 23 in.

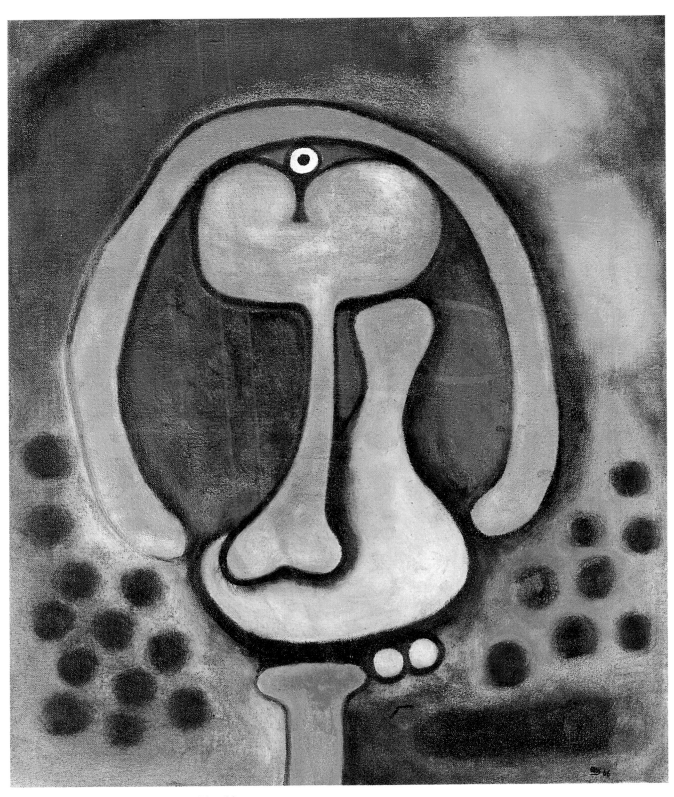

47 **Introvert**, 1966. Oil on canvas, 24 × 20 in.

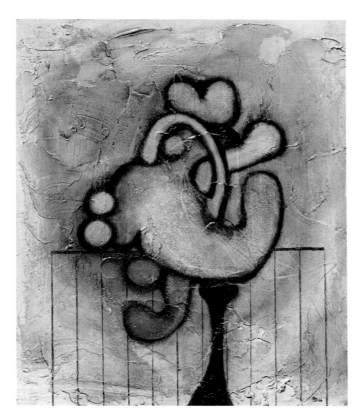

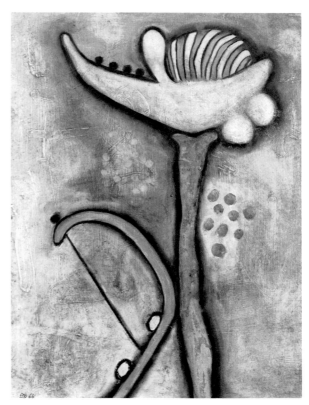

48 **Intimate Decision**, 1966. Oil and plaster on canvas, 18 × 15 in.

49 **Warrior Waiting**, 1966. Oil on board, 24 × 18 in.

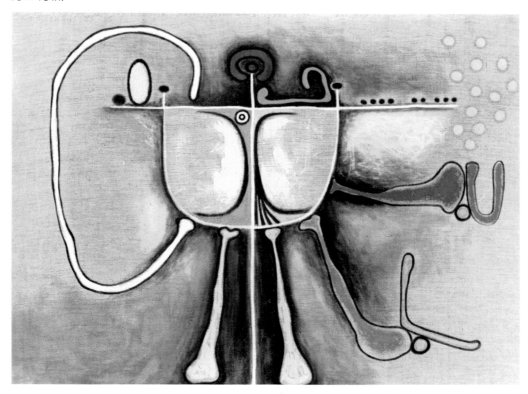

50 **Extrovert**, 1966. Oil on canvas, 36 × 48 in.

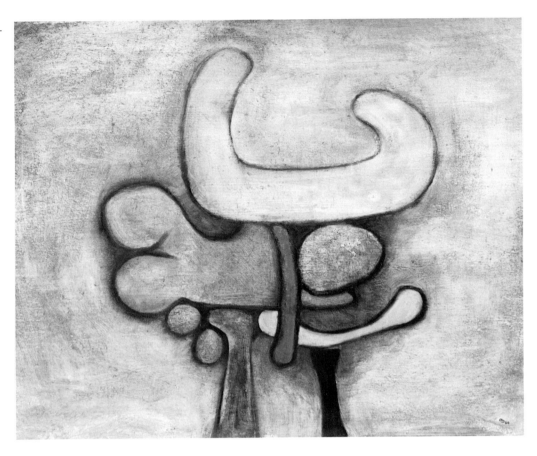

51 **Organic Statue**, 1966.
Oil on card, 17 × 21 in.

### The Barnet studio, 1965–1968

The move to a new house and a new studio in the north London suburb of Barnet in 1965 had a strangely liberating effect on my subject-matter. The dour series of black paintings and arid series of white paintings of 1961–2 had gradually faded and been replaced by much warmer, more erotic images in 1965–6. The biomorphs were still being viewed, as it were, in close-up, but with colourful, fleshy shapes being depicted. Strangely there is no hint in them that my health was about to suffer from over-work. Perhaps this was because I was over-working, not through anxiety or economic need, but simply because I enjoyed all the (too many) projects I was undertaking.

Following the unexpected success, in 1967, of one of these projects – a book called *The Naked Ape* – I was able to remove myself altogether from the pressures of London and retreat for the next six years to a large villa on the Island of Malta. There, in a new studio, a new type of painting began to develop. The great walls of the thirty-roomed villa demanded huge paintings to cover them. The previous owners, it emerged, had removed over 300 pictures when they left. I began to work on large subjects with a much greater freedom of treatment. The relaxed life of the sun-baked Mediterranean world inevitably had its impact on my painting style. The images became looser, sometimes even lyrical, as this new life-style worked its magic. Six pictures from this period are included (Figs 52–56, Fig. 118).

49

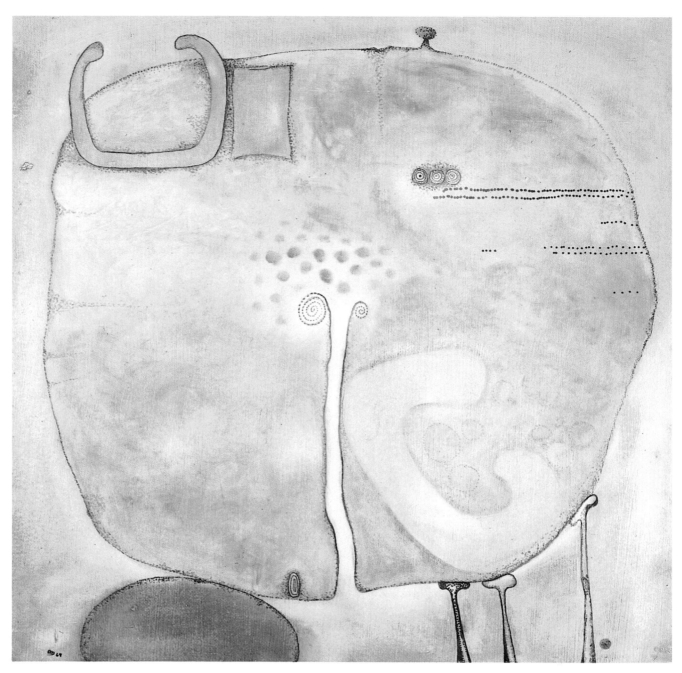

52 **Earth Mother**, 1969. Oil on board, 29 × 29 in.

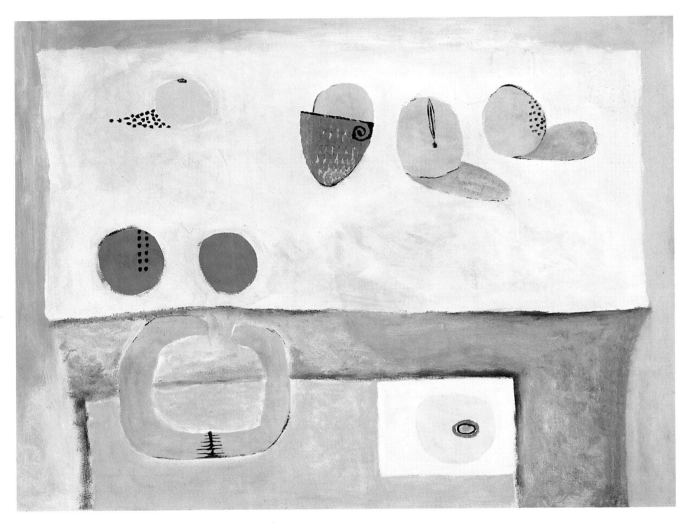

53 **Table Pleasures**, 1969. Oil on board, 45 × 59 in.

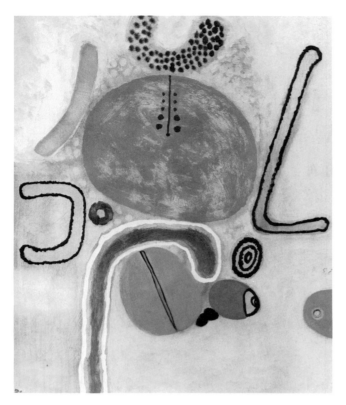

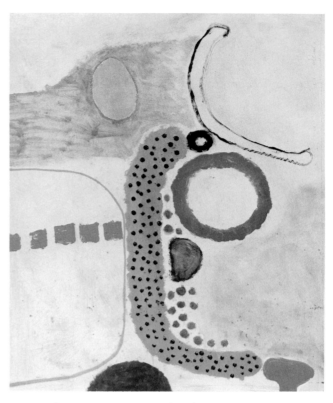

54 **Birthday Emotions**, 1969. Oil on board, 33 × 27 in.

55 **Daydream Zone**, 1969. Oil on board, 33 × 27 in.

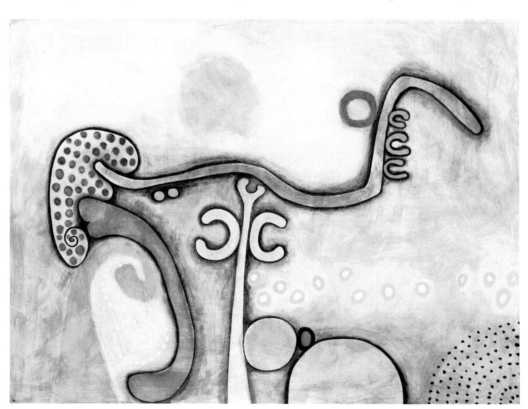

56 **Festival**, 1969. Oil on board, 45 × 60 in.

### The Malta studio, 1968–1973

As the walls of the Villa Apap Bologna in Malta were gradually re-hung with large new paintings, a strange and sudden change in the pictures took place. In 1969, for reasons I cannot explain, I took an early painting of mine from the biomorphic 1947 phase called *The Mistress*, and completely re-painted it, re-naming it *The Teacher's Doubt* (Fig. 57). Although by this point in my life I had completed over 600 pictures, I had never before re-painted one. Once a picture was finished it was finished, and that was that. There were never any second thoughts. If I lost interest in it, I simply destroyed it, usually by painting it out and then re-using the canvas. This time, however, I carefully re-worked the early scene. It was as if, after many experiments and excursions, I wished now to return to my first love — to my simply presented biomorphs in their smoothly featureless dream-world. And return I did, from that day to this. There were still a few injections of the large-scale, loosely painted lyrical works inspired by the sweet life of the Mediterranean and its seductive light, but gradually the original, meticulous biomorphic style reasserted itself until, by 1972, it had regained total domination. From that date until 1986 there has been no further experiment in styles, merely a progressive unfolding of scene after scene of the personal world into which I plunged myself with *Entry to a Landscape* at the beginning of 1947. Despite the idyllic conditions on Malta and the hot sun beating down outside, it was this introspective world that now obsessed me once more in my studio. And when I finally returned to Oxford in 1973 and set up a big new studio there, the geographical change made not the slightest impact on the style or content of my paintings. They seemed at last to have become completely independent of the outer world and were virtually painting themselves. Sometimes, on entering the studio, I quite expected an unfinished canvas to have gone on peopling itself with new biomorphs during the night, as if they had finally developed their own power of reproduction.

**57  The Teacher's Doubt**, 1969. Oil on canvas, 12 × 26 in.

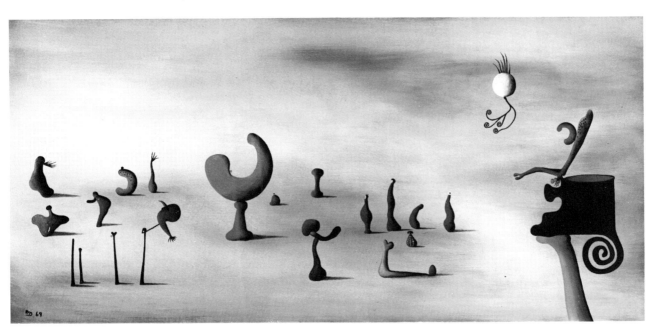

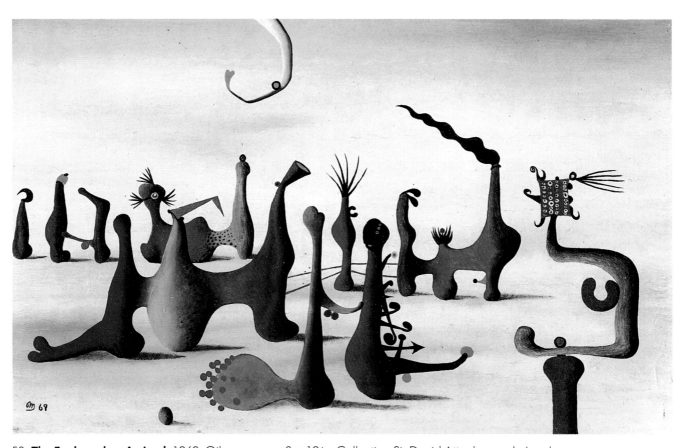

58 **The Explorer has Arrived**, 1969. Oil on canvas, 8 × 12 in. Collection Sir David Attenborough, London.

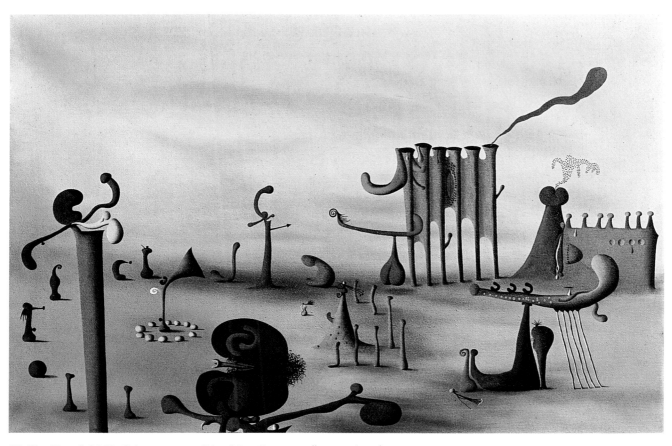

59 **The Ritual**, 1969. Oil on canvas, 24 × 36 in. Private collection, London.

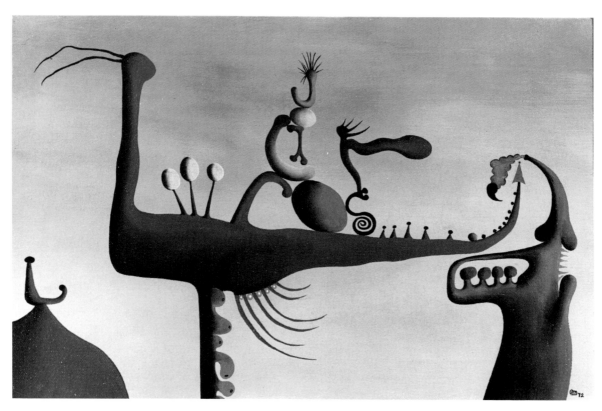

60 **The Attentive Friend**, 1972. Oil on canvas, 12 × 18 in. Collection Mrs Marjorie Morris, Oxford.

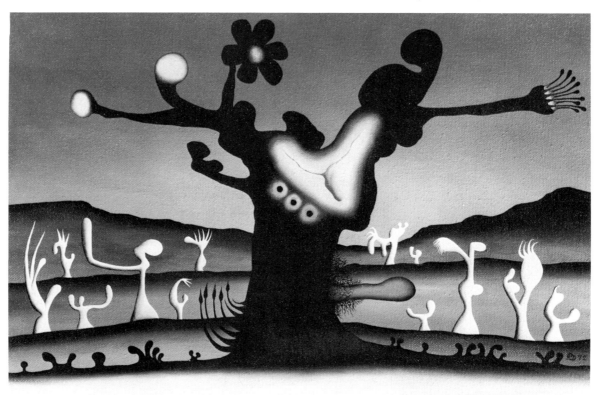

61 **The Guardian of the Cycle**, 1972. Oil on canvas, 12 × 18 in.

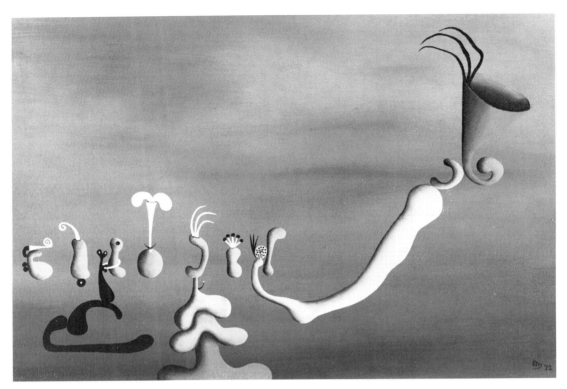

62 **The Unimportance of Yesterday**, 1972. Oil on canvas, 12 × 18 in.

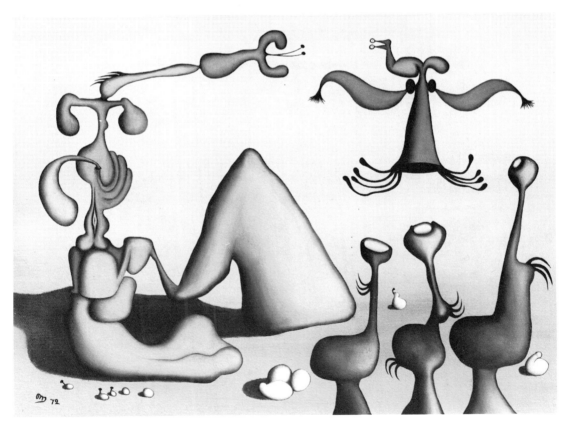

63 **The Insensitive Intruder**, 1972. Oil on canvas, 12 × 16 in.

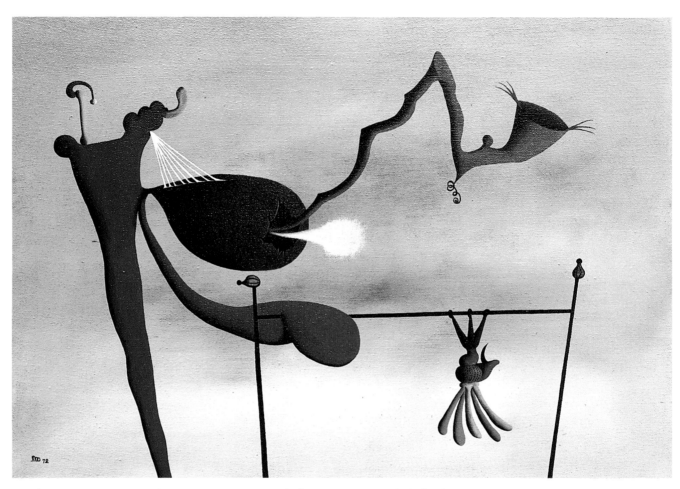

64 **The Protector**, 1972. Oil on canvas, 16 × 22 in. Collection Equinox Ltd, Oxford.

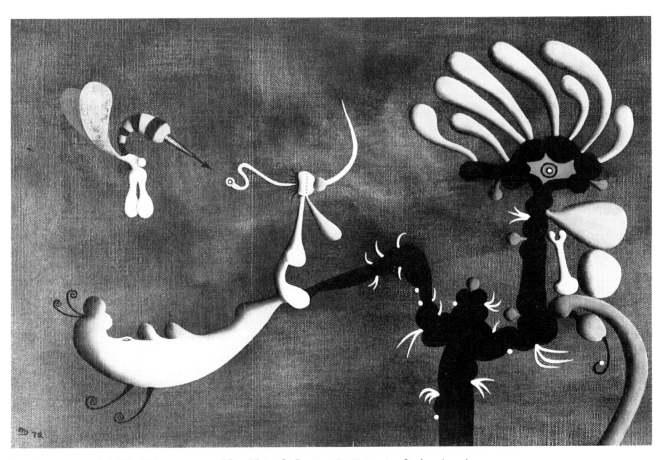

65 **Sting Appeal**, 1972. Oil on canvas, 12 × 18 in. Collection Dr Kate MacSorley, London.

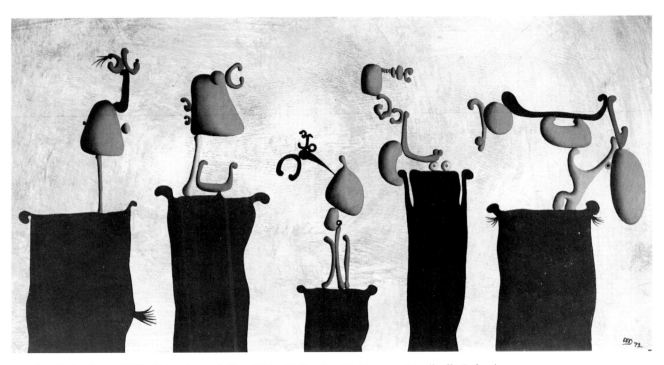

66 **The Onlookers**, 1972. Oil on board, 11 × 21 in. Collection Mr Herman Friedhoff, Oxford.

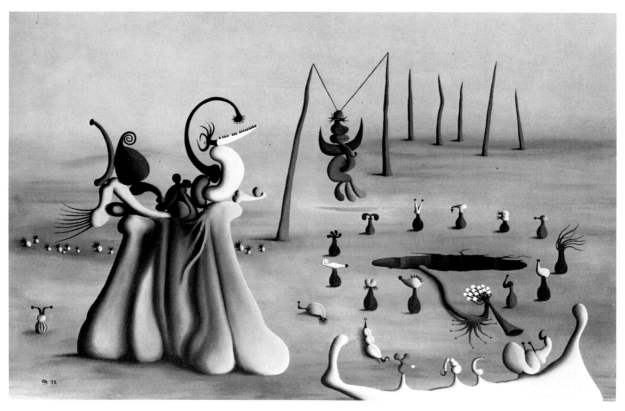

67 **The Ceremony of the Hole**, 1972. Oil on canvas, 20 × 30 in.

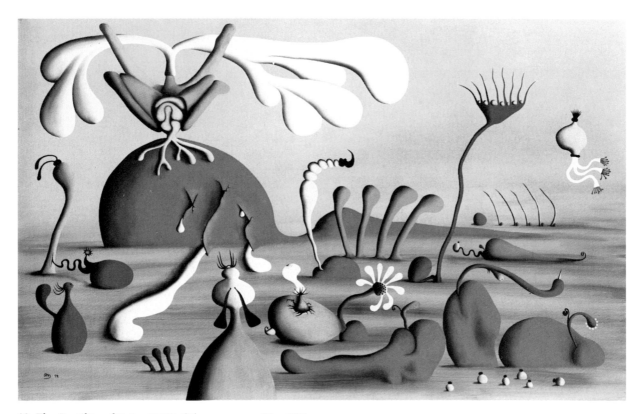

68 **The Fertility of Pain**, 1972. Oil on canvas, 20 × 30 in.

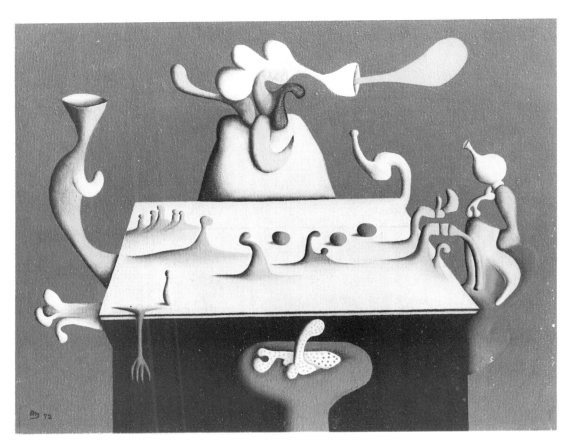

69 **The Visitor**, 1972. Oil on canvas, 12 × 16 in.

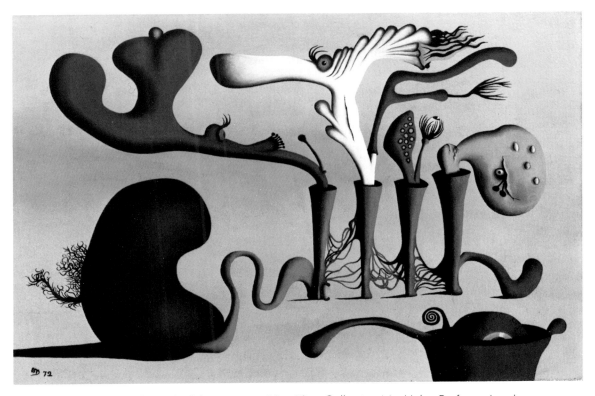

70 **Polymorphic Growth**, 1972. Oil on canvas, 12 × 18 in. Collection Mrs Helen Profumo, London.

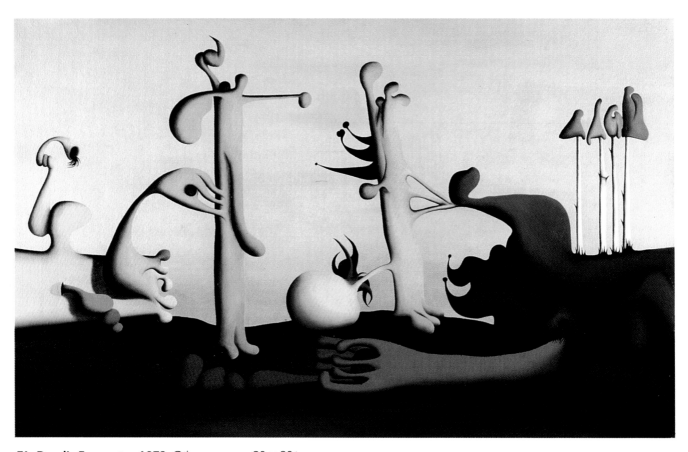

71 **Dyadic Encounter**, 1972. Oil on canvas, 20 × 30 in.

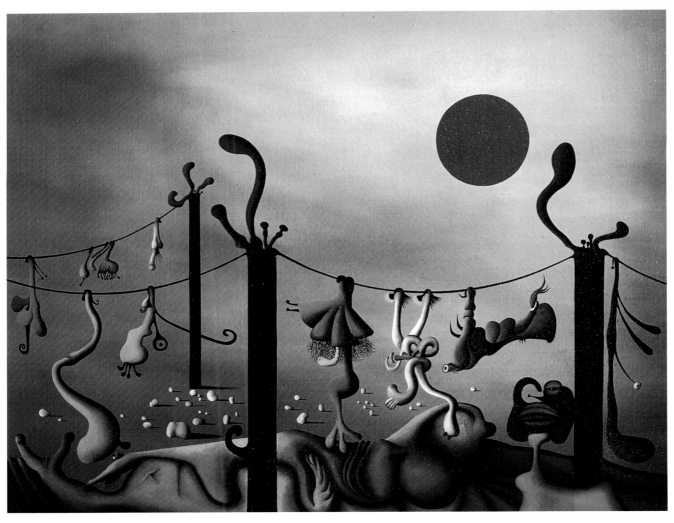

72 **The Collector's Fallacy**, 1972. Oil on canvas, 24 × 30 in. Private collection, London.

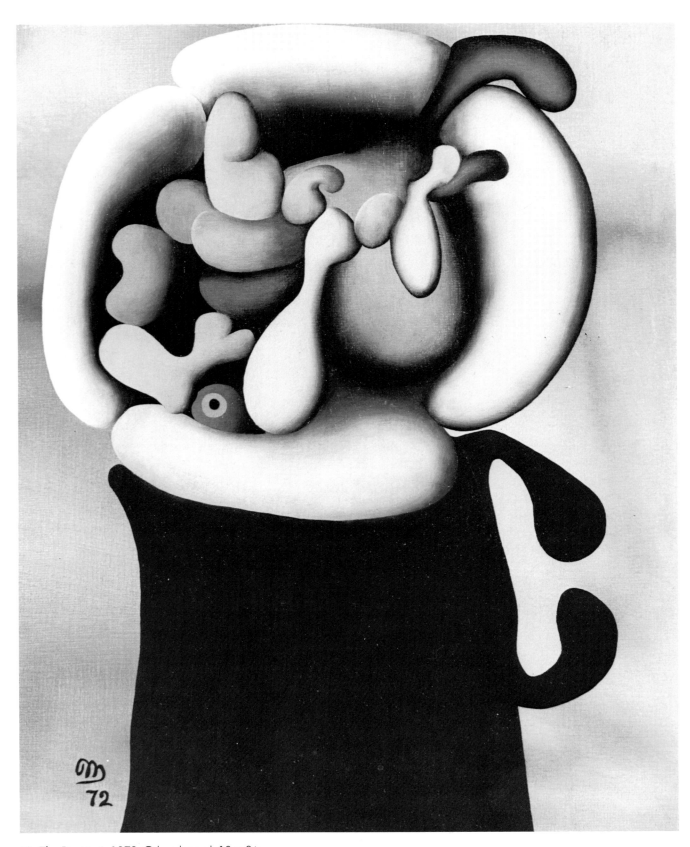

73 **The Protégé**, 1972. Oil on board, 10 × 8 in.

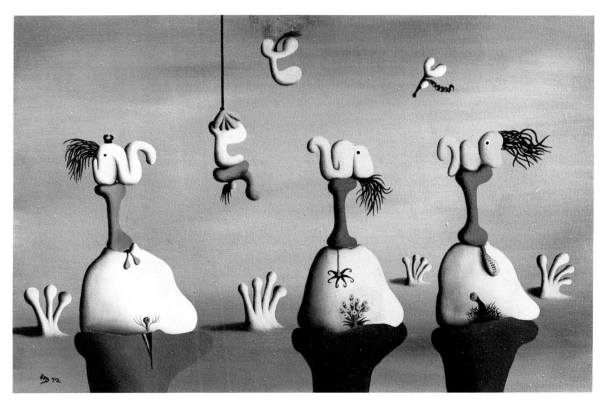

74 **The Three Members**, 1972. Oil on canvas, 12 × 18 in.

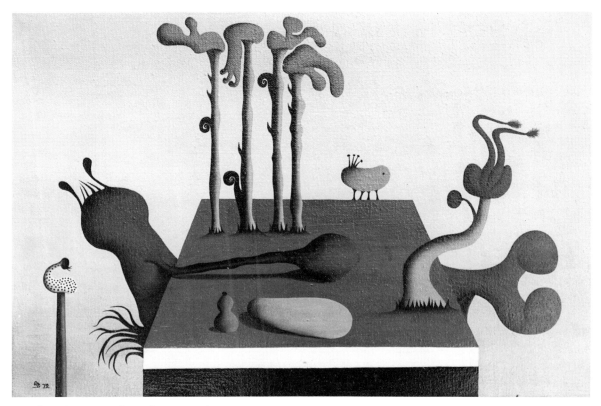

75 **The Obsessional Meal**, 1972. Oil on canvas, 12 × 18 in. Collection Mr Richard Veen, Amsterdam.

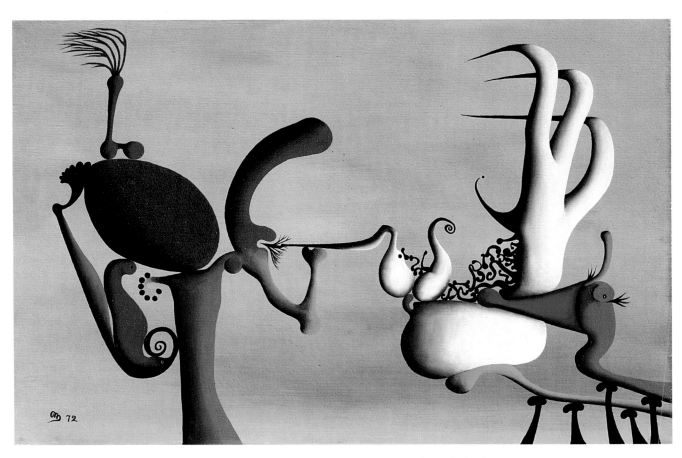

76 **The Titillator**, 1972. Oil on canvas, 12 × 18 in. Collection Dr Richard Dawkins, Oxford.

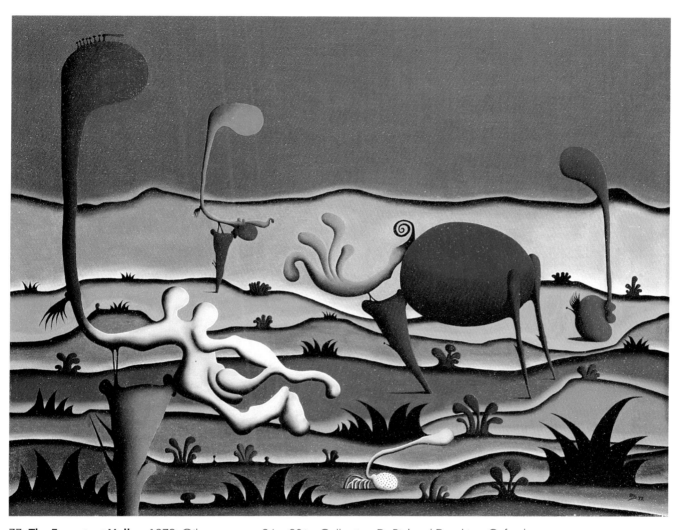

77  **The Expectant Valley**, 1972. Oil on canvas, 24 × 30 in. Collection Dr Richard Dawkins, Oxford.

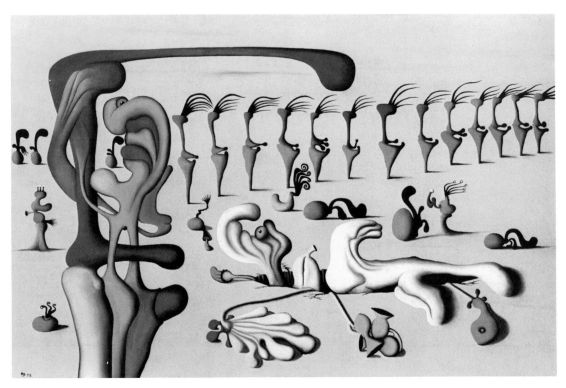

78 **The Parade of Memories**, 1972. Oil on canvas, 20 × 30 in.

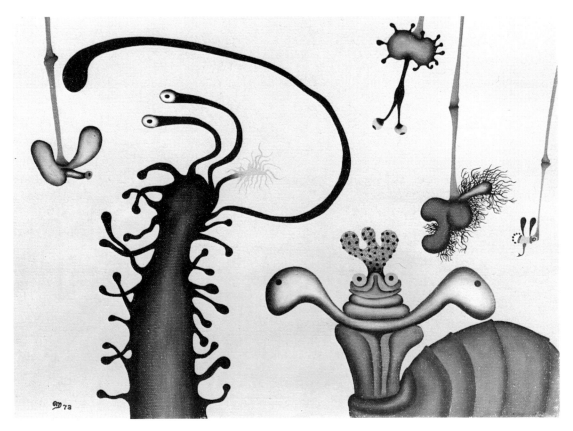

79 **Deciduous Decisions**, 1973. Oil on canvas, 12 × 16 in.

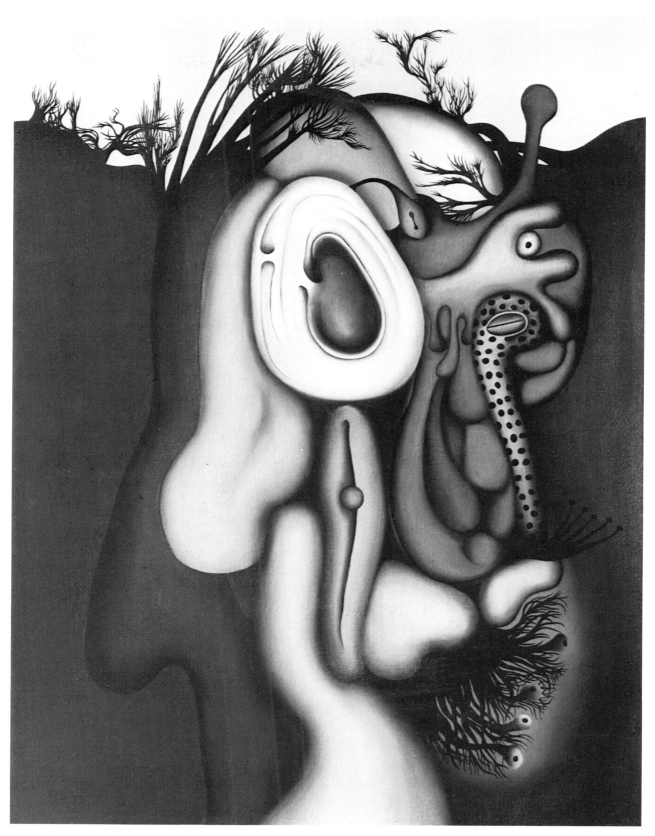

80 **The Budding Force**, 1973. Oil on canvas, 16 × 12 in. Private collection, Oxfordshire.

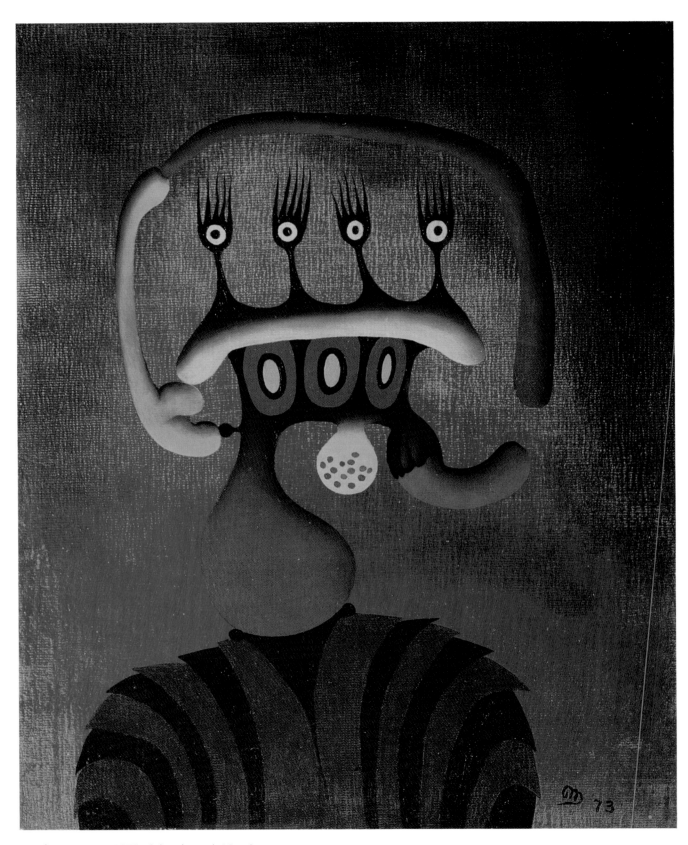

81 **The Agitator**, 1973. Oil on board, 10 × 8 in.

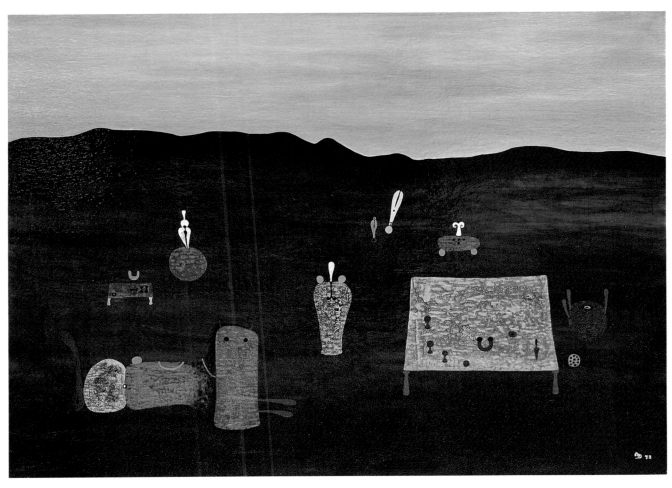

82 **The Erosion of Longing**, 1973. Oil on canvas, 16 × 22 in. Collection Mr Hans Redmann, West Berlin.

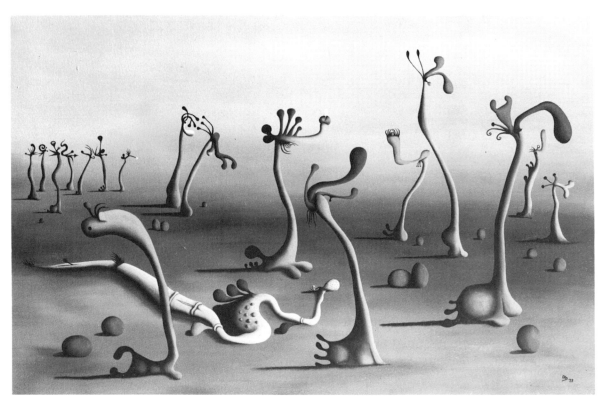

83 **Disturbance in the Colony**, 1973. Oil on canvas, 20 × 30 in. Collection Mrs Marjorie Morris, Oxford.

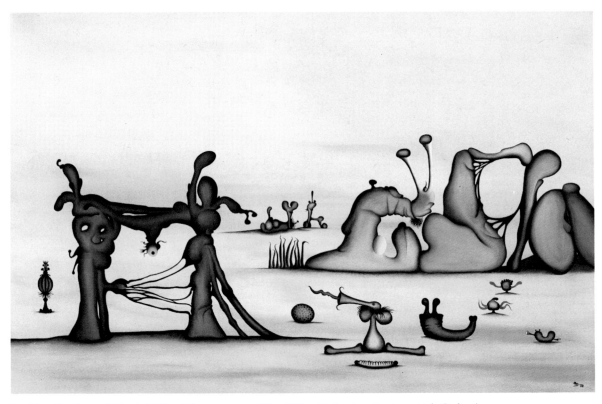

84 **The Neglected Rival**, 1973. Oil on canvas, 20 × 30 in. Collection Equinox Ltd, Oxford.

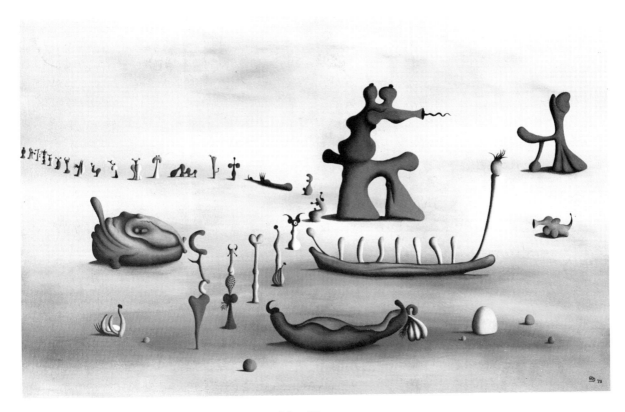

85 **The Familiar Stranger**, 1973. Oil on canvas, 20 × 30 in.

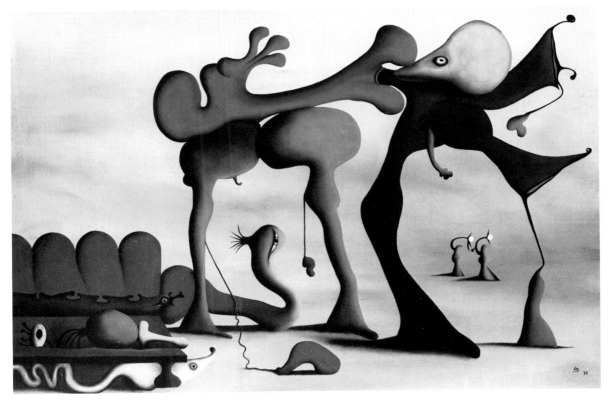

86 **The Observers**, 1973. Oil on canvas, 20 × 30 in.

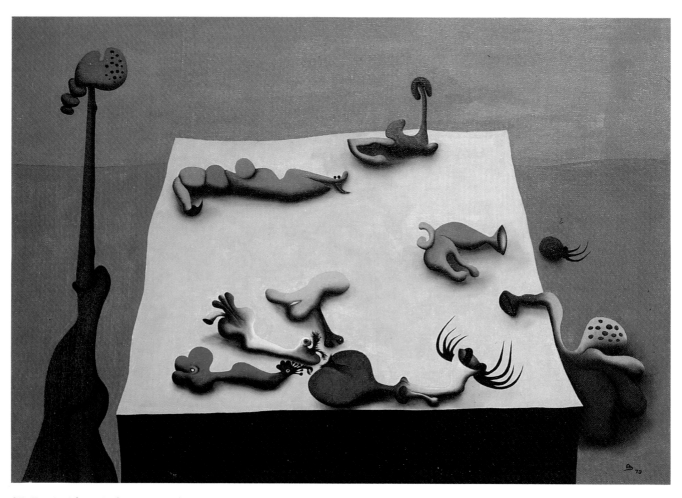

87 **For Insiders Only**, 1973. Oil on canvas, 16 × 22 in. Collection Professor and Mrs E.V. van Hall, Noordwijk, Holland.

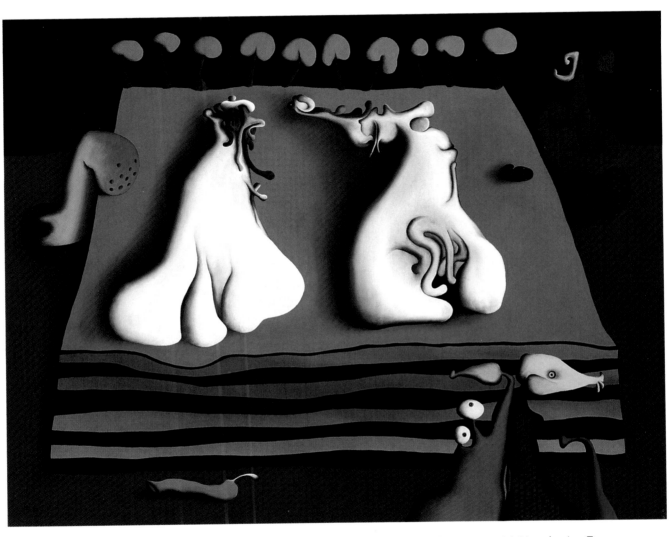

88 **Lovers' White Dreamtime**, 1973. Oil on canvas, 24 × 30 in. Collection Mr and Mrs James M. Vaughn Jnr, Texas.

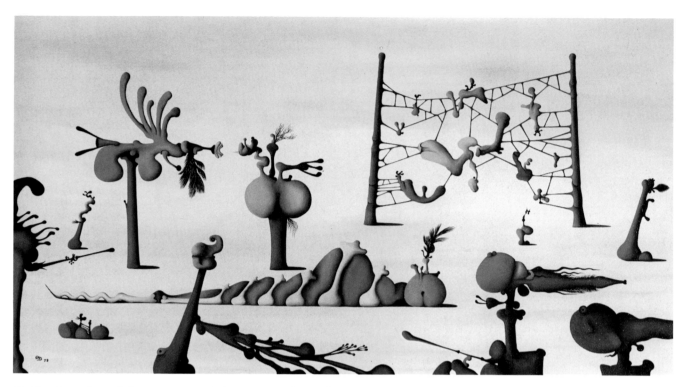

89 **The Guardian of the Trap**, 1973. Oil on canvas, 20 × 36 in.

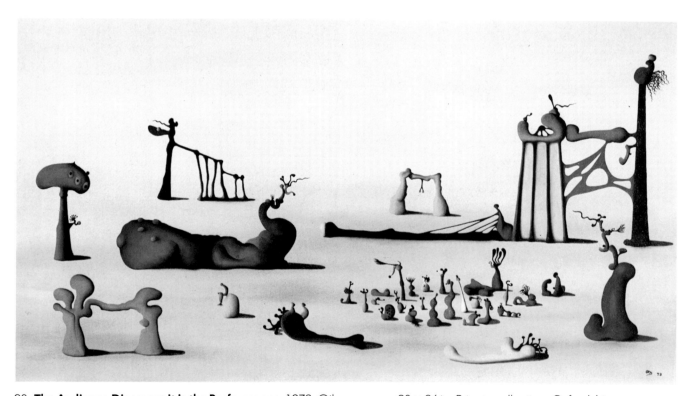

90 **The Audience Discovers it is the Performance**, 1973. Oil on canvas, 20 × 36 in. Private collection, Oxfordshire.

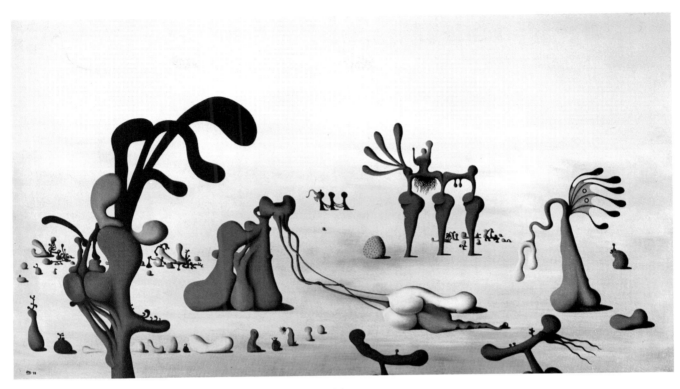

91  **The Moment of Partial Truth**, 1973. Oil on canvas, 20 × 36 in.

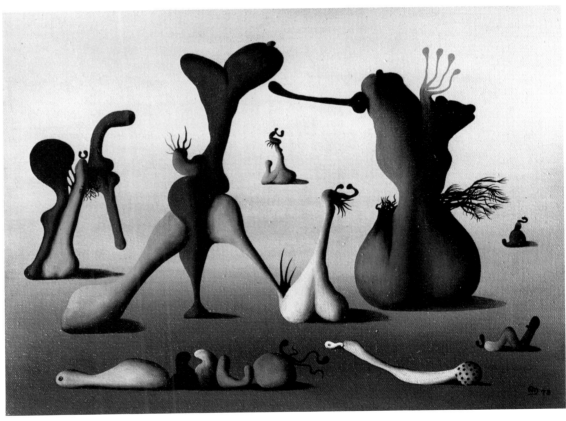

92  **The Day After Yesterday**, 1973. Oil on canvas, 12 × 16 in.

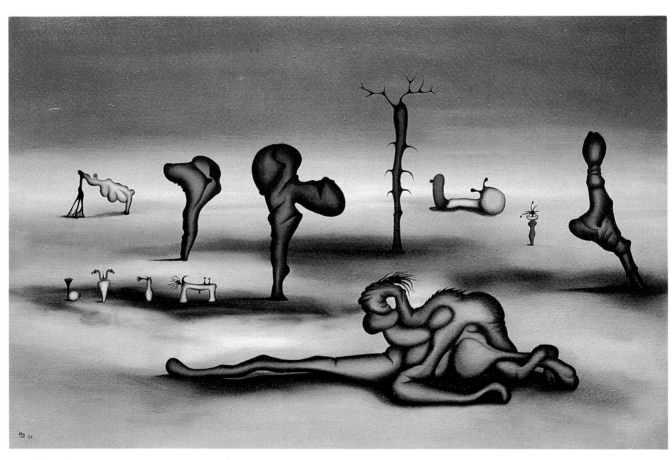

93 **The Kill**, 1973. Oil on canvas, 20 × 30 in. Collection Christopher Moran and Co Ltd, London.

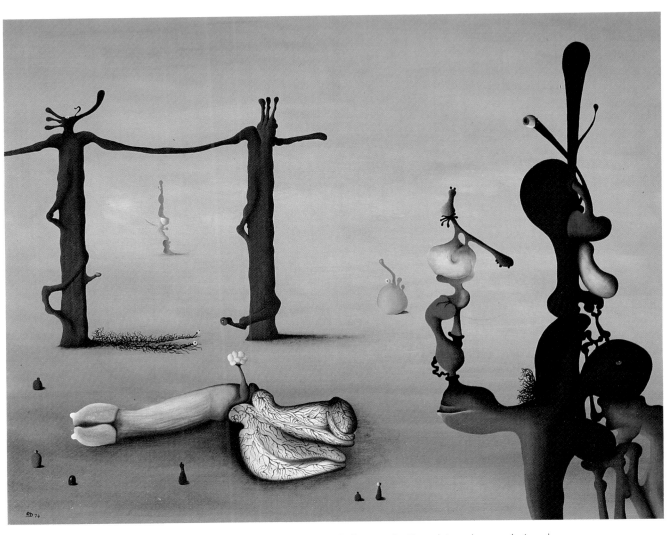

94 **Metamorphic Landscape**, 1974. Oil on board, 23 × 29 in. Collection Sir David Attenborough, London.

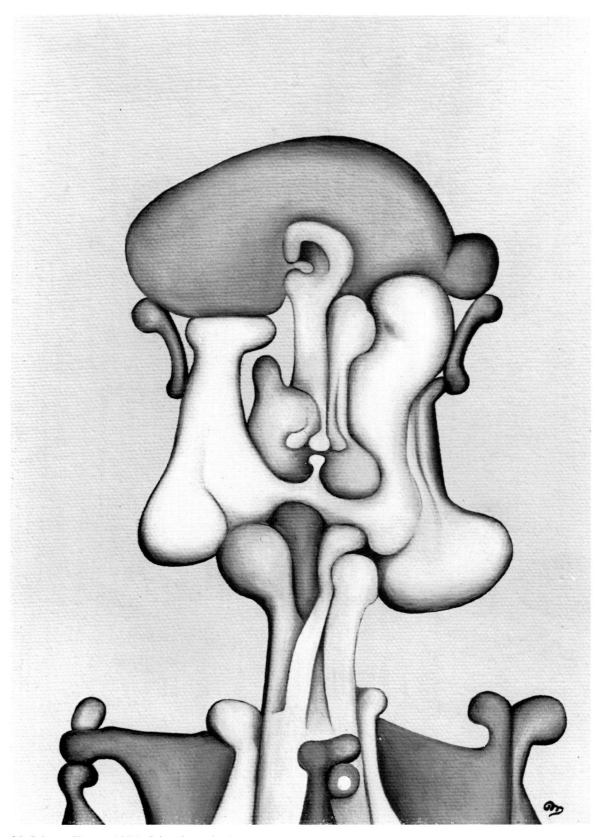

95 **Private Figure**, 1976. Oil on board, 10 × 7 in.

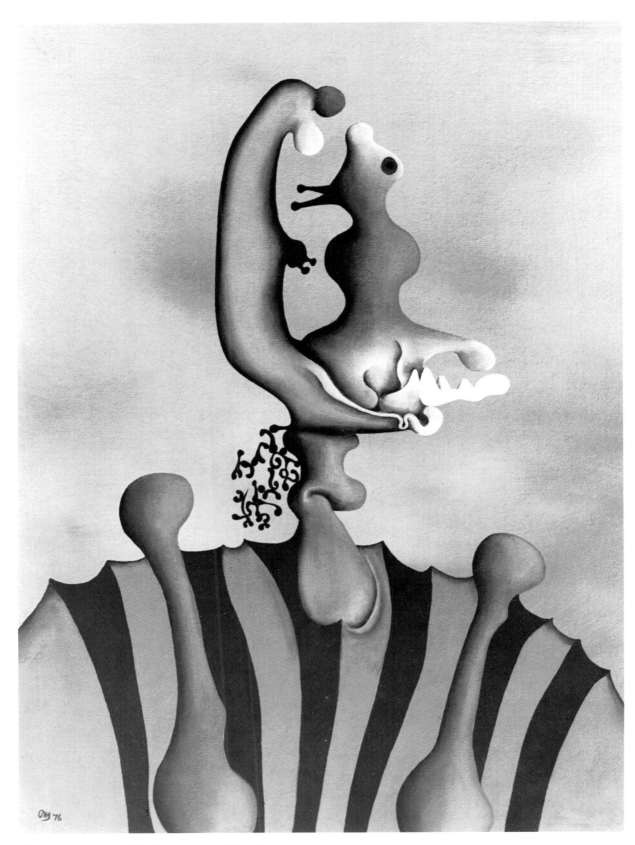

96 **Public Figure**, 1976. Oil on board, 16 × 12 in.

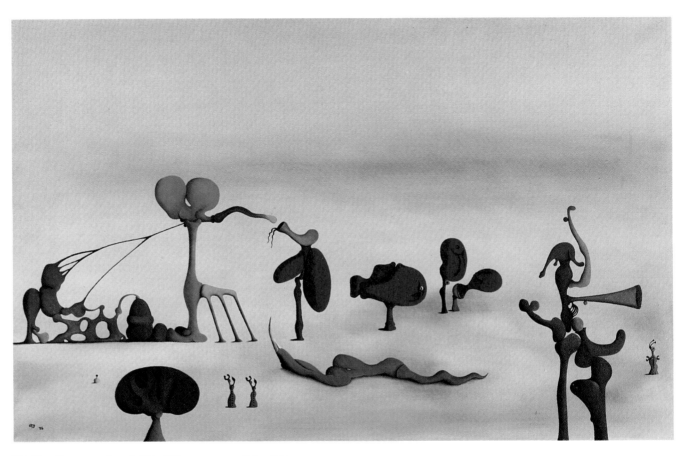

97 **The Presentation**, 1976. Oil on canvas, 24 × 36 in.

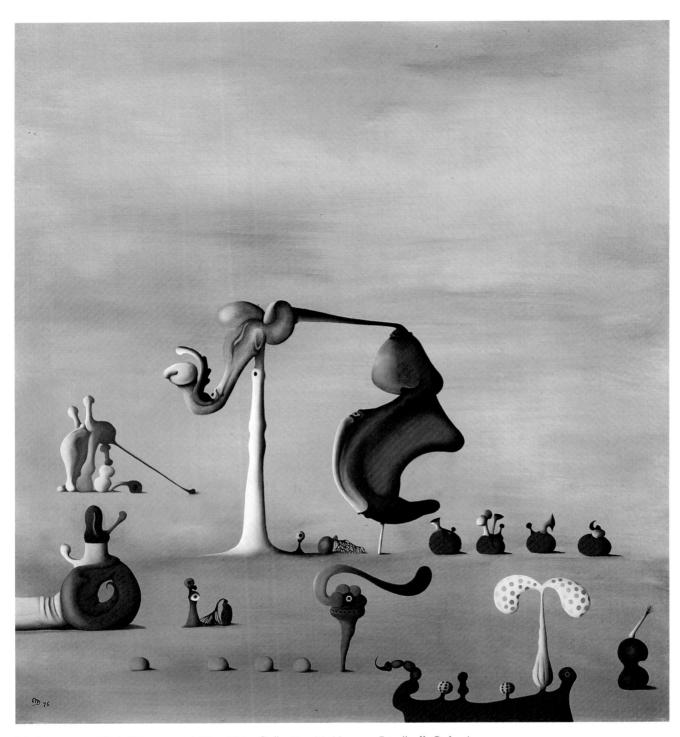

98 **Ancestors**, 1976. Oil on panel, 20 × 22 in. Collection Mr Herman Friedhoff, Oxford.

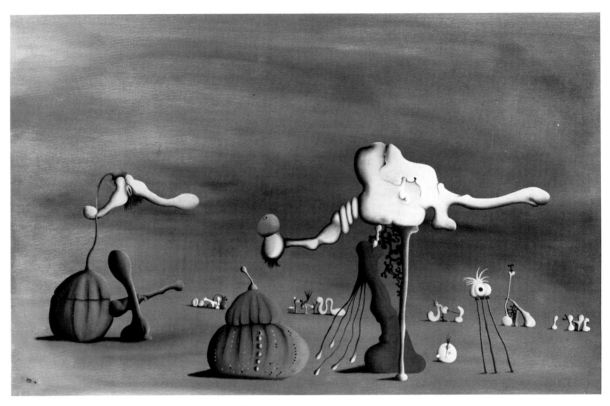

99 **Contestants**, 1976. Oil on canvas, 24 × 36 in.

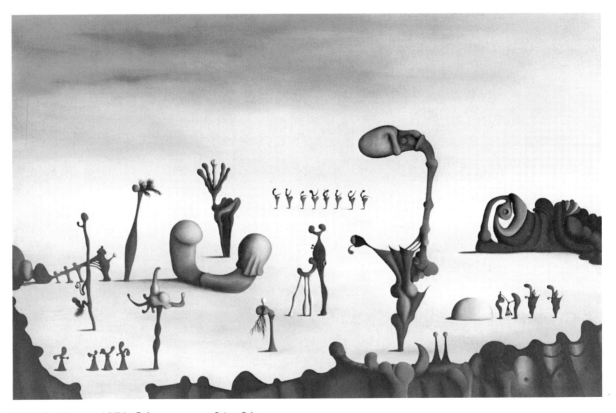

100 **The Arena**, 1976. Oil on canvas, 24 × 36 in.

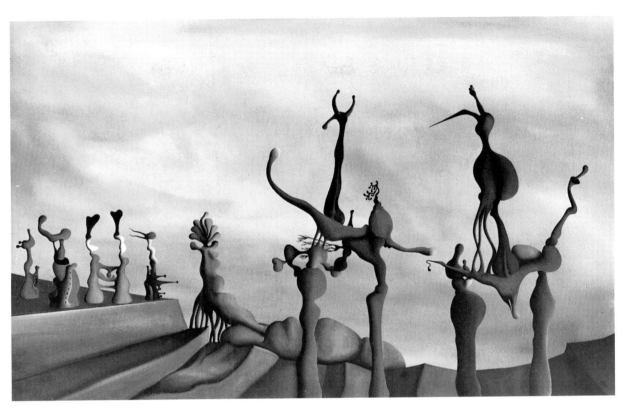

101 **Ascending Figure**, 1976. Oil on canvas, 24 × 36 in.

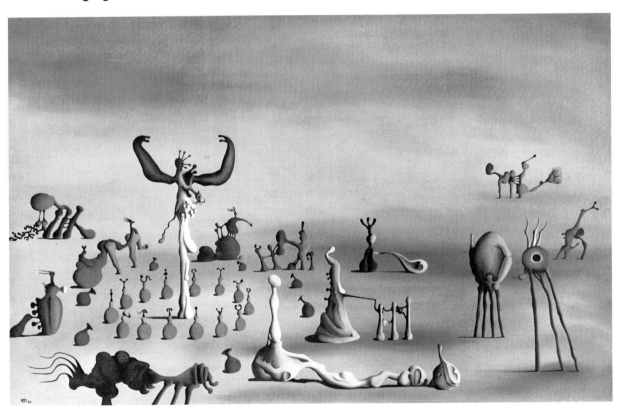

102 **Totemic Decline**, 1976. Oil on canvas, 24 × 36 in.

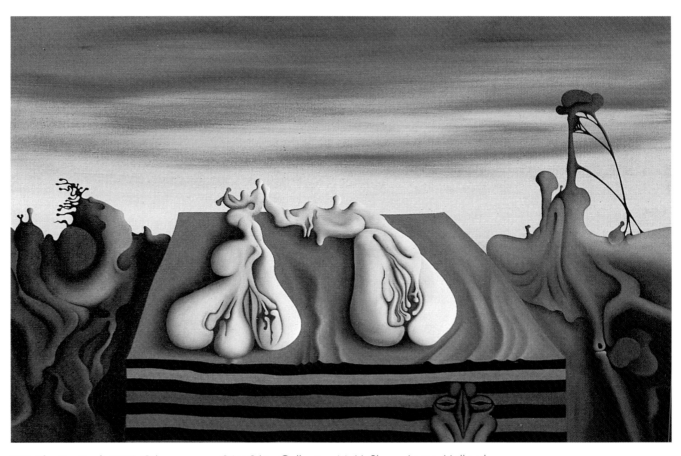

103 **The Sentinel**, 1976. Oil on canvas, 24 × 36 in. Collection Mr H. Slewe, Laren, Holland.

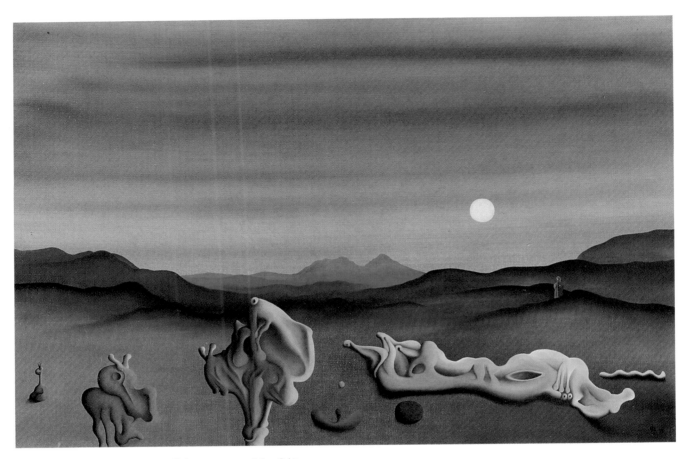

104 **The Sleepwalker**, 1976. Oil on canvas, 24 × 36 in.

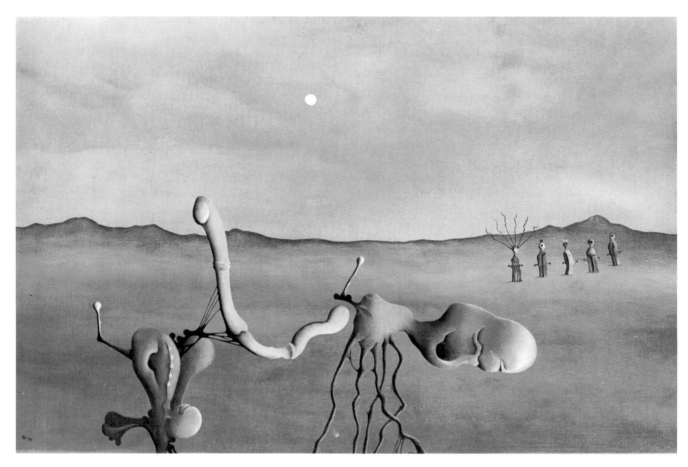

## The second Oxford studio, 1973–1987

The year 1976 saw a further series of large biomorphic landscapes, but between 1977 and 1984, only one canvas was produced – *Aggro* (Fig. 105). Despite its isolation, it showed no change of style. The gap in the production of paintings was not due to some major change of mood, but simply to a greatly increased output of writing. Eight books were completed during this period, including a large one on the subject of ancient art which involved the production of approximately 1,300 detailed, illustrative drawings of artefacts. I found that each of these drawings, on average, took me a whole evening to complete, which, although it kept my picture-making hand fully-trained, absorbed any spare time there might have been for painting.

When I returned to my studio easel again in 1985, it was at first on a modest scale, with three small brown figures (Figs 106–108). I was relieved to find that the biomorphs had not deserted me and I welcomed them back with a large picture, *The Seven Sisters* (Fig. 109). There was a strong feeling of greeting old friends who, in the passing of the years, had undergone some changes but were still familiar to me. These paintings proved to me conclusively that the consistency of my personal world was established. It now had its own existence and I could, at any time, open another window on it and study it from another angle, adding new biomorphs to the existing fauna, like some Victorian naturalist exploring an unmapped region for the first time.

105 **Aggro**, 1981. Oil on canvas, 24 × 36 in. Collection Dr and Mrs Peter Marsh, Oxford.

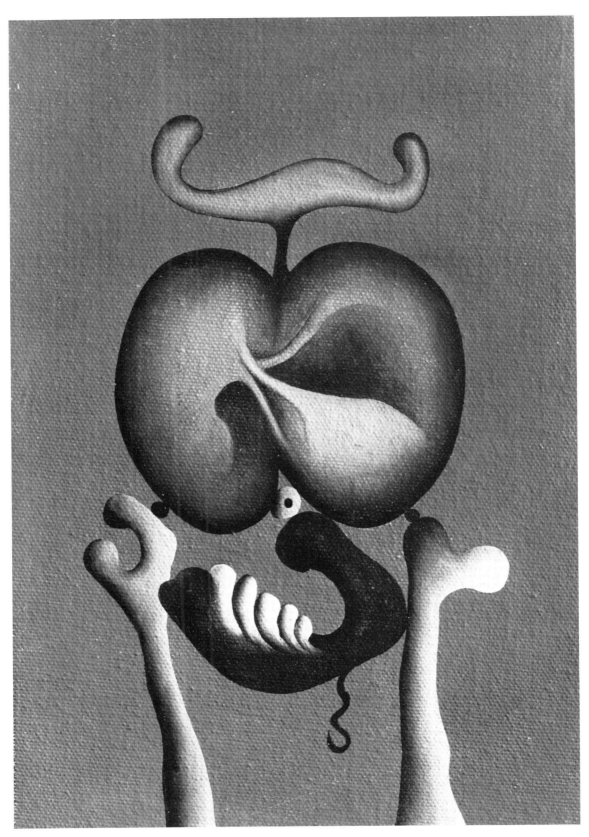

106 **Hybrid Vigour**, 1985. Oil on board, 10 × 7 in.

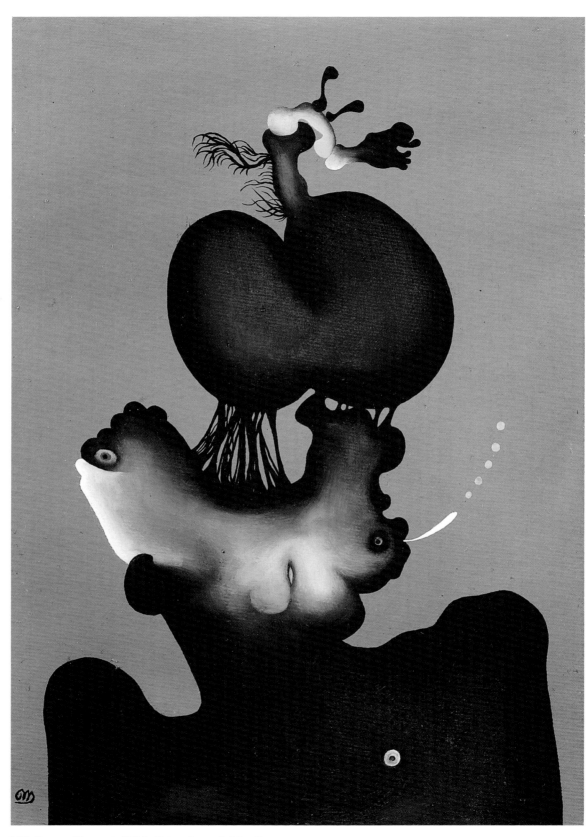

107 **Brown Figure I**, 1985. Oil on board, 10 × 7 in.

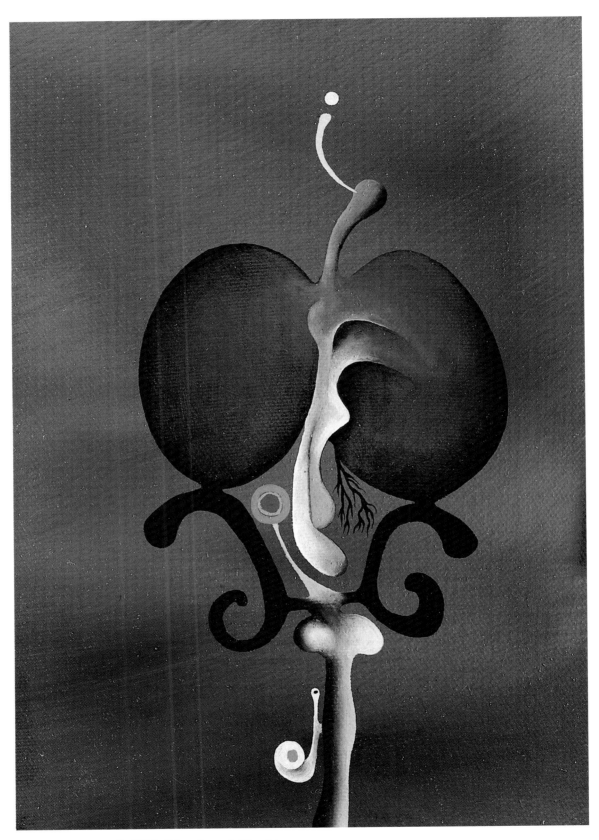

108 **Brown Figure II**, 1985. Oil on board, 10 × 7 in.

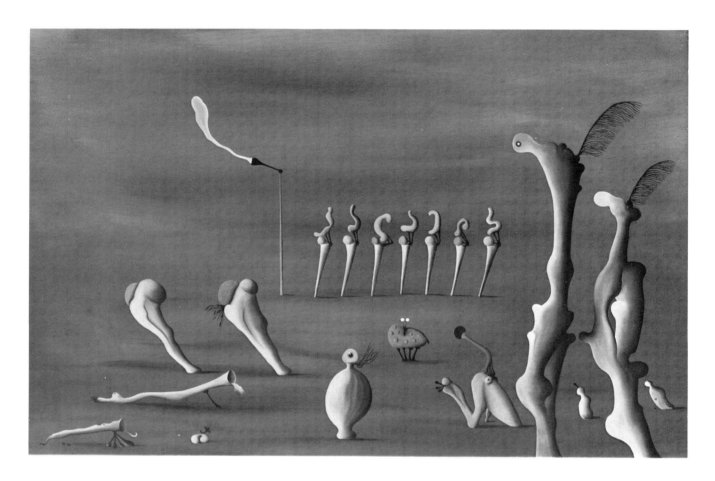

109 **The Seven Sisters**, 1985. Oil on board, 24 × 36 in.

Looking back over forty years of painting I must admit to the persistence of one nagging frustration – my inability ever fully to enter my private, biomorphic world. Long ago, in the 1940s, I made several half-hearted attempts to achieve this. To everyone's consternation, I painted my bedroom jet black – the walls, the doors, the woodwork, everything (Fig. 113). Then I painted vivid coloured images on this black background and solemnly contemplated the scene before falling asleep each night, in the hope that it would induce dreams that would transport me to my private world. It failed miserably except on one occasion when I was suffering from a fever. My unusually high temperature induced a nightmare state of mind in which I did indeed find myself in the presence of one of my biomorphs. When I awoke, I scribbled down the details: 'There is one enormous creature I can just see out of the corner of my eye . . . it has a single claw and a red head with big teeth fixed all around it, which, strangely, seem quite sad . . . .' As I gazed up at it in the dream, it started to fall very slowly down on top of me. I blacked out and when I came round (still in the dream) I discovered that I had now become the creature. Gazing down I found that instead of legs and human feet, I was the possessor of a single large claw. The dream had gone a step too far. I had no wish to *become* one of my biomorphs, merely to be able to observe their world, to wander around in it – but while remaining myself.

I tried another tack. I had myself hypnotized with instructions to the hypnotist

beforehand that he was to order me to enter my biomorphic world for a brief tour of inspection. This also failed, but another instruction – to paint scenes from my personal world while still under hypnosis, did produce some results. Unfortunately the paintings were so crudely made that they were of little interest, except to show that the same type of images was the main preoccupation.

At a later date, someone suggested that I should try drugs, to see if I could hallucinate into my biomorphic world. Two of my scientific colleagues had employed hallucinogens under controlled laboratory conditions with great effect. They reported the way in which they had been transported into a peculiar dream-world where they had experienced many exciting visual dramas. Knowing of the fauna of strange images that haunted my undrugged mind, they felt certain that, with chemical assistance, I would be able to visit my personal world and then return again after an unusually rich set of experiences. They may have been right, but for some reason I have a mortal fear of all drugs. It was many years before my wife could persuade me even to take an aspirin for a headache, so hallucinogenic drugs were clearly out of the question.

My final way of solving the problem was to write about my 'other world'. Back in 1967, sitting on a beach in Cyprus, I had scribbled a fantasy in a small notebook. In 1982, I sat alone in a Monaco hotel room and completed it, turning it into a full-length book called *Inrock*. In it, my hero finds himself entering a bizarre realm inside the rocks, inhabited by creatures not unlike my biomorphs. The journey I took while writing this story was a remarkably pleasant one and is probably the nearest I will ever get to my juvenile wish to leap through the picture-frame. But even this was not entirely satisfactory. Somehow, the moment my hero started to talk to the biomorphs they became too human. In order to sustain the adventure as a story, this narrative device was badly needed, but it forced me in a strange way to anthropomorphize my biomorphs, just as Disney anthropomorphizes ordinary animals in his cartoon films. In the end I realized that these were not my real biomorphs, but Disneyfied versions of them – entertaining enough, but lacking the deeply serious intentions of my paintings.

So there seems to be no hope, except to go on painting my private world and continuing to exert the same strict discipline I have always imposed on it. This discipline makes the production of each painting a totally absorbing, but quite exhausting procedure, because I have continually to assess the validity of every brush-stroke – the truthfulness of every addition to the image that is taking shape. For the portrait- or landscape-artist, this truth lies in the outside world that is being copied. For me there is no such point of reference. The truth lies mysteriously somewhere inside my brain. All I know is that, should I add a detail – a spike or a lobe, a bulge or a striation – which is discordant, I sense it immediately. It rarely happens now, but when it does I remove the new feature quickly before the paint has had time to dry. If I fail to do this, then the whole painting has to be destroyed. What really puzzles me is *how* I know when something is amiss. But know I do, just as surely as when a portrait-painter sees that his painted image is failing to capture the personality of his sitter. It is this, I suppose, that has kept the consistency of imagery in my paintings from 1947 to 1987.

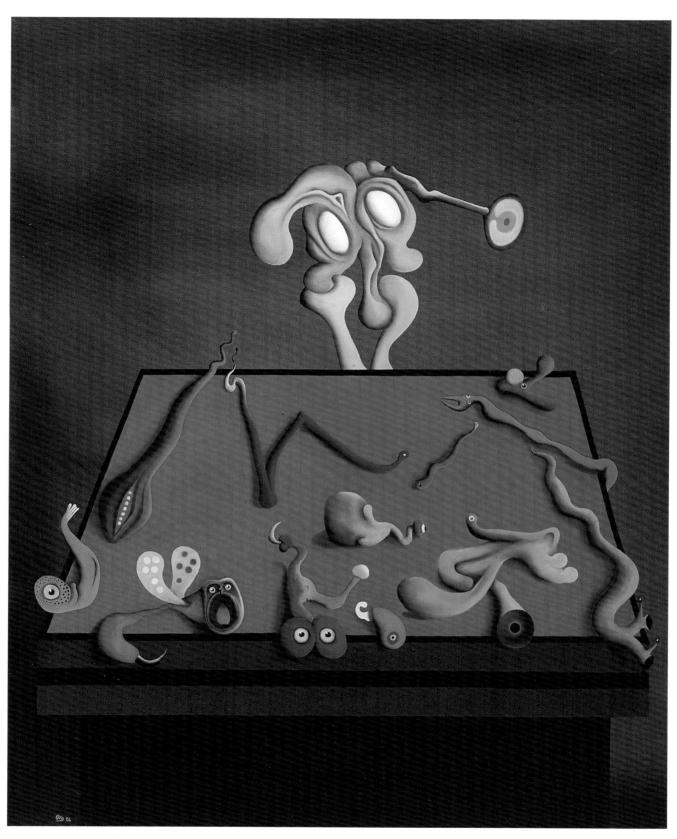

110 **The Blind Watchmaker**, 1986. Oil on canvas, 30 × 24 in.

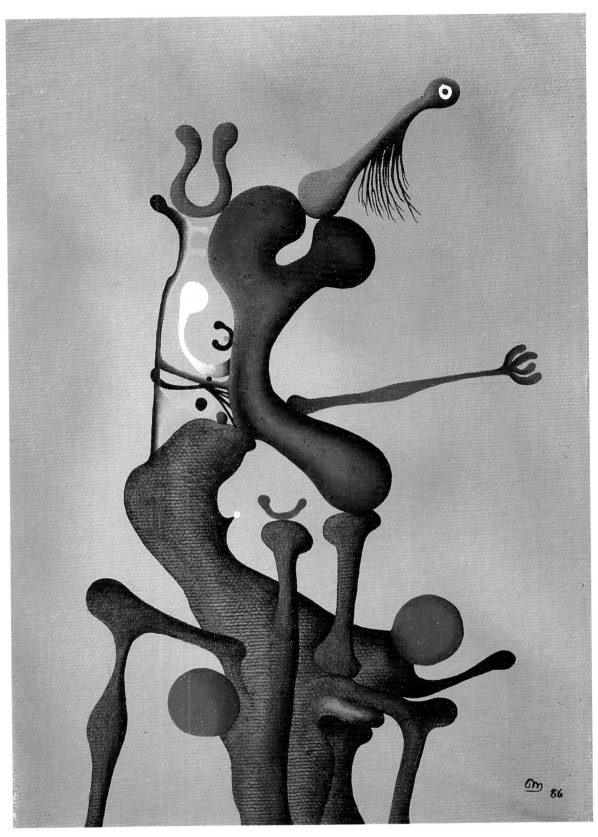

111 **The Orator**, 1986. Oil on board, 10 × 7 in.

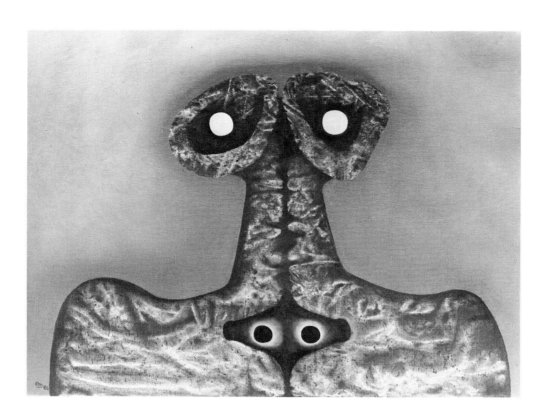

This concludes the Gallery of paintings. Although the 110 illustrated here represent only about one fifth of the surviving works, they do include almost all my favourite pictures and cover almost every phase. If there is any bias it is slighty in favour of the typically biomorphic scenes, since I consider these to be central to the work as a whole. I have been less generous with space with the experimental phases, because I now consider them to have been side-tracks from the main theme. And I have omitted completely the immature work before 1947.

Until I came to search for missing paintings to include in this volume, I had never realized just how many pictures I have mislaid over the years. Some that I managed to track down astonished me as I had completely forgotten what they contained. I knew with certainty that they were by my hand, but I had no recollection of the act of painting them. My apparent carelessness is due to the fact that, throughout the forty years that I have been making pictures, my primary purpose has been to explore my personal world. Once a painting has helped me to do this, I quickly grow tired of it and move on to another. This does not mean that I grow to dislike it, merely that it has fulfilled its function. At that point it is touch and go whether I put it away in a cupboard, tear it up, paint over it or give it away to a friend. On the rare occasions when I have held exhibitions, a number of pictures have been sold and those too have often disappeared completely after a number of years. In the Checklist of paintings at the end of this volume, I have marked with an asterisk all those paintings whose whereabouts is now unknown to me.

# Biographical notes

**1928** Born in southern England at Hillside House in the village of Purton, near Swindon, Wiltshire, on January 24th, the son of Harry Morris, an author of children's fiction. Early childhood spent in the Wiltshire countryside.

**1933** Moved to Swindon, which remained his home until 1951. Attended the local High School and kept a large menagerie of animals. Spent much of his spare time observing the wildlife at a nearby lake owned by his family. An important family influence was that of his great grandfather, William Morris, who had founded the local newspaper and was also an enthusiastic Victorian naturalist. Discovered William's microscope in an attic and became obsessed with the strange world of minute creatures it revealed to him.

**1941** Was sent as a boarder to Dauntsey's School in Wiltshire where his interest in zoology in general, and the microscopic world in particular, was intensified.

**1944** Began to produce imaginative drawings for the first time, while at school. Official disapproval of these early pictures served only to encourage him.

**1945** Without tuition, switched to oil-painting and started to devote more and more time to picture-making. Converted a conservatory at his Swindon home into his first studio.

**1946** Conscripted into the army for two years of National Service, but continued to paint at every opportunity.

**1947** Transferred to the Education Corps and appointed as a Lecturer in Fine Arts at the Chiseldon Army College. The head of his Department, Mervyn Levy, the art critic, encouraged him in his painting and introduced him to a local patron of the arts, James Bomford, who owned one of the major collections of modern paintings in the country. Under Bomford's influence and through the contacts he made with the many artists who visited the Bomford mansion, he decided to abandon his ambitions for a zoological career and to devote himself exclusively to painting.

**1948** In January he held his first One-man-show of Surrealist paintings at his home town of Swindon. Although the BBC broadcast a favourable review of the exhibition, local reaction was extremely hostile. Despite this, the Swindon authorities permitted him to organize a second exhibition which opened in August. This time his pictures were accompanied by the work of several other young Surrealists who had attended his classes at the Chiseldon Army College,

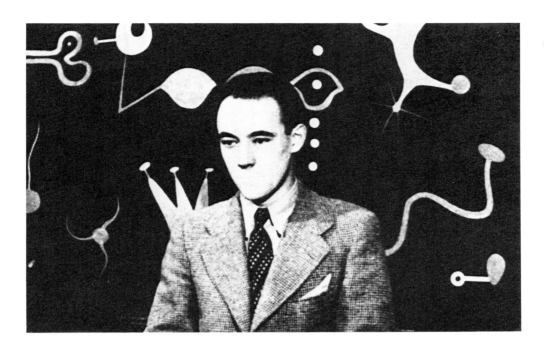

including Ted Kingan and Gilbert Speechley. The response on this occasion was even more aggressive, with demands in the local press that all the paintings on show should be 'destroyed in a furnace'. No paintings were sold and it was becoming rapidly clear that in the post-war social climate of England, Surrealism was an acutely unwelcome art form. Rather than modify his style of painting to suit popular taste, he decided to abandon all hope of becoming a full-time painter and to return instead to his zoological studies. In the autumn, on leaving the army, he enrolled as an undergraduate in the Zoology Department of Birmingham University.

**1949** As a zoology student he spent many hours drawing the organisms he encountered while working at the microscope, and spent every free moment of his vacations painting in his Swindon studio. In Birmingham he joined the group of artists centred on the home of the Surrealist, Conroy Maddox, and exhibited some of his recent paintings at a Group exhibition in February 1949, organized by the Birmingham Artists' Committee. Other members of the group included Oscar Mellor, Emmy Bridgwater, John Melville and William Gear.

**1950** In February he held his first London exhibition, jointly with Joan Miro, at Edouard Mesens' London Gallery in Brook Street, which had been the nerve-centre for British Surrealist activity for several years. Through Mesens met Roland Penrose, Lee Miller and George Melly. Wrote and directed two Surrealist films, *Time Flower* and *The Butterfly and the Pin*.

**1951** Exhibited at Bristol as part of the Festival of Britain activities and at an International Arts Festival in Belgium. Obtained first-class degree in Zoology at Birmingham University. Participated in the Birmingham Artists' Committee

Group show before leaving to start post-graduate zoological research at Oxford University. Transferred his Swindon studio to Oxford.

**1952** Held an exhibition of new paintings at the Ashmolean Museum, Oxford, in May and June, jointly with Scottie Wilson and Geoffrey Clarke. In July married Oxford history graduate, Ramona Baulch, and moved to house on the outskirts of Oxford, where he continued to paint. Published his first scientific paper this year, to be followed by forty-seven others over the next fifteen years.

**1953** For the first time, scientific research dominated painting activity. There was time only for drawings, including a large number of academic illustrations to papers on animal behaviour.

**1954** Awarded a doctorate for his researches into aspects of reproductive behaviour. Post-doctoral research projects begun at the University, with painting once again reduced to a minimum.

**1956** Moved to London to take up appointment as head of the newly-formed Granada TV and Film Unit at the Zoological Society of London. Started investigation to study the picture-making abilities of chimpanzees as part of a project to analyse the origins of aesthetics. Presented his first television programme on animals, to be followed by 500 more over the next eleven years.

**1957** Organized an exhibition of paintings and drawings by chimpanzees at

114 At the London Gallery exhibition in 1950. The large painting, called **The City** (1948) has since been destroyed.

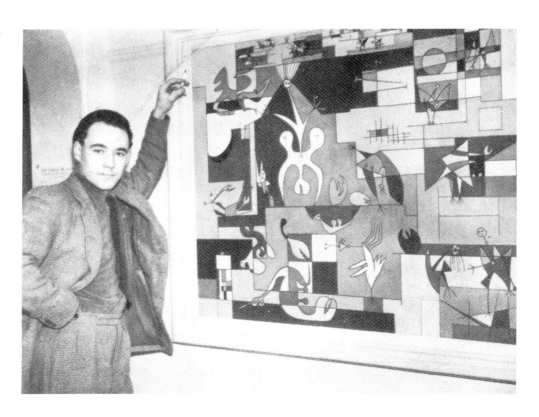

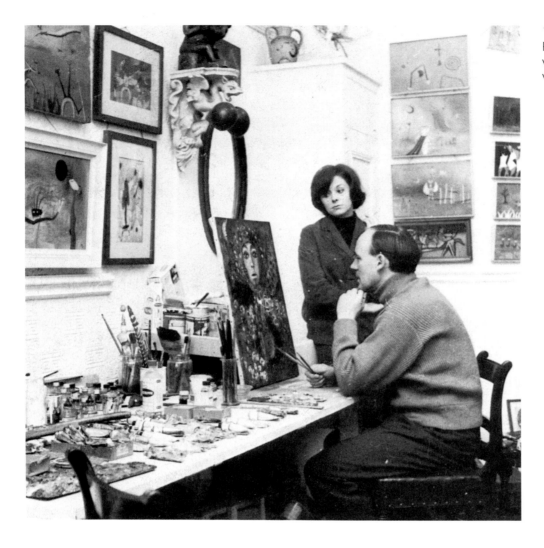

115 With Ramona in the Primrose Hill studio in 1960 working on a self-portrait which has since been lost.

the Institute of Contemporary Arts in London, combining for once his twin interests in art and zoology. In this year he also began painting actively again himself, in his apartment at Primrose Hill near Regent's Park.

**1958** Was co-organizer, with Mervyn Levy, of *The Lost Image* exhibition at the Royal Festival Hall, London, comparing pictures by apes, human infants and human adults. Also published his first scientific book, to be followed by twenty-five others over the next twenty-eight years.

**1959** Appointed Curator of Mammals at the Zoological Society of London, a post which he held for the next eight years.

**1960** Set up a large new studio at Primrose Hill, which he shared with author Philip Oakes.

**1962** Published *The Biology of Art*, a study of the picture-making behaviour of the great apes and its relationship to human art. Also wrote an article for *The*

*Studio* magazine about his own pictures entitled 'The Private Painter'. In this he commented:

> To this day, painting has remained for me an act of rebellion, a private pursuit which I indulge in despite the fact that there are many good reasons why I should not do so. The simple, direct creative act of painting a picture is a childlike ritual of exploration .... It can act, for an adult, as a gesture of defiance against the increasing intrusion into everyday life of good, sound common sense .... The whole process of how my paintings come into being is still a mystery to me. When I leave for my studio, my mind becomes a blank

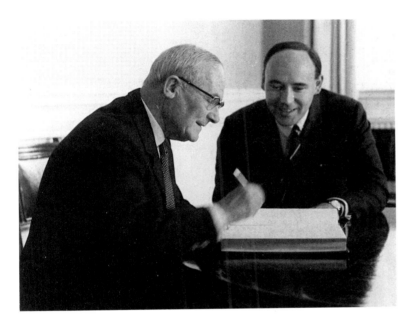

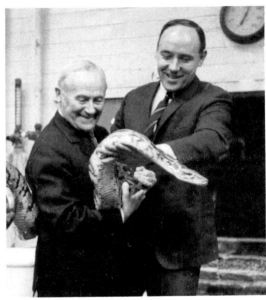

116 With Joan Miro in London, in September 1964.

117 Wrapping Joan Miro in the coils of a giant python, Regent's Park, September 1964.

and, after hours of painting, a picture has grown out of nothing and stares at me. I stare back at it, cautiously surprised and puzzled at where it has sprung from. The process of painting itself is an almost unconscious act and is certainly free from any verbalization ... [it] is automatic, compulsive ....

**1964** Visited by Joan Miro who wished to acquire a painting by his chimpanzee, Congo. Recalling that one of Miro's earliest drawings, made in 1908 when the Spanish artist was only fifteen, was of a huge, coiling snake, he arranged for Miro to be wrapped in the coils of a giant python at the London Zoo's Reptile House.

**1965** Moved from Primrose Hill to a larger home at Barnet, north of London, where in a new studio his painting activity was greatly increased.

**1967** On a sudden impulse, abandoned his zoological career and took up a new appointment as the Director of the Institute of Contemporary Arts in London, with the encouragement of its President, Sir Herbert Read, and its

Chairman, Sir Roland Penrose. Was put in charge of organizing the removal of the Institute from its cramped quarters in Dover Street, to an impressive new home in The Mall, close to Trafalgar Square. Unexpectedly, this acquiring of official status in the London art world had a deadening rather than a stimulating effect upon his own painting activities. Not a single picture was produced during this year and doubts about the wisdom of the move were beginning to grow when an unforeseen event occurred. Late in the year his book about human behaviour entitled *The Naked Ape* was published and overnight became a best-seller (eventually selling over 10,000,000 copies). For the first time in his life the financial considerations that had prevented him from becoming a full-time painter were swept away. He resigned his post at the ICA and made arrangements to leave England and set up a studio in the Mediterranean.

**1968** Moved with his wife to a large villa on the Island of Malta, where his son Jason was born. In his new studio he was now able to paint almost full-time, interrupting the work occasionally to write a new book.

**1971** In a rare statement about his art, he published an article in the *Observer*

118 Outside the Malta studio, at the Villa Apap Bologna, Attard in 1970. The large painting, just completed, is **Greenery Pastimes**.

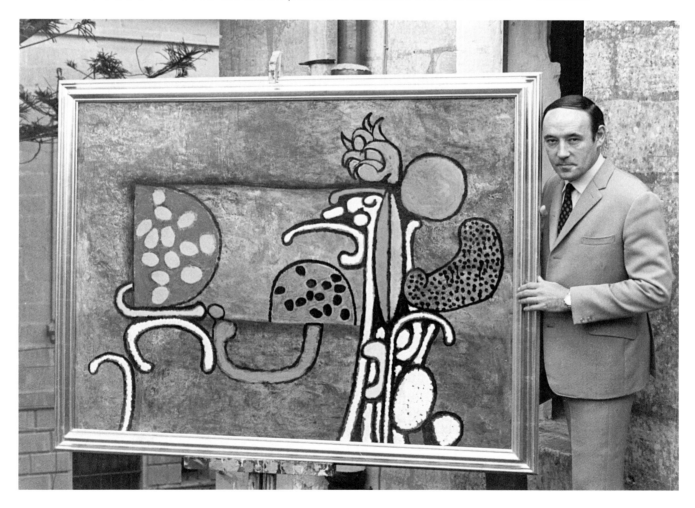

magazine called 'The Naked Artist', which he concluded with the comment:

> In a curious way I do not fit into any of the accepted categories of the art world. I am not a professional ... my last exhibition was twenty years ago — nor, in the ordinary sense, am I a 'Sunday painter'. For those who like labels, I suppose I can best be described as a private painter. According to my passport, of course, I have always been a zoologist and remain so. If my paintings do nothing else they will at least serve to demonstrate that such titles are misleading. In reality, people today are not scientists or artists ... they are explorers or non-explorers, and the context of their explorations is of secondary importance. Painting is no longer merely a craft, it is a form of personal research. Picasso may appear to have contradicted this when he said that he does not seek, he finds. But so in a sense does the scientist — the creative moment in research is rarely the end of a quest, but more often a moment of unexpected discovery, of revelation almost, if that is not too pompous a word. So, in the end, I do not think of myself as being part scientist and part artist, but simply as being an explorer, part objective and part subjective.

**1973** After six years of Mediterranean life he became restless and returned to take up a Research Fellowship at Wolfson College at Oxford and to work again in the Zoology Department there. He set up a large new studio in a converted Victorian coach house in north Oxford, next door to the house where he and his family had made their new home. Despite good intentions, he discovered it was increasingly difficult to rekindle the excitement he had felt when carrying out his earlier research into animal behaviour twenty years previously, and found himself withdrawing more and more from the Department of Zoology to the privacy of his studio. There, his painting activity became intense once more and he considered exhibiting again for the first time for many years.

**1974** Held a One-man-show of new paintings at the Stooshnoff Fine Art Gallery in Brook Street, London. Published a statement about his work in an article called 'Biomorphia' in the Oxford magazine *Lycidas*.

**1976** Held four more exhibitions during this year: One-man-show of paintings from the 1950s and 1960s at Wolfson College, Oxford; One-man-show of new paintings at the Quadrangle Gallery, Oxford; One-man-show of new paintings at the Lasson Gallery, Jermyn Street, London; and a retrospective exhibition of sixty-one works covering thirty years of painting (1946–1976) at the Public Art Gallery in Swindon, his home town.

**1978** Held a One-man-show at the Galerie D'eendt in Amsterdam. Also exhibited at a Surrealist show at the Camden Arts Centre in London. Took a trip around the world.

**1979** Took another trip around the world.

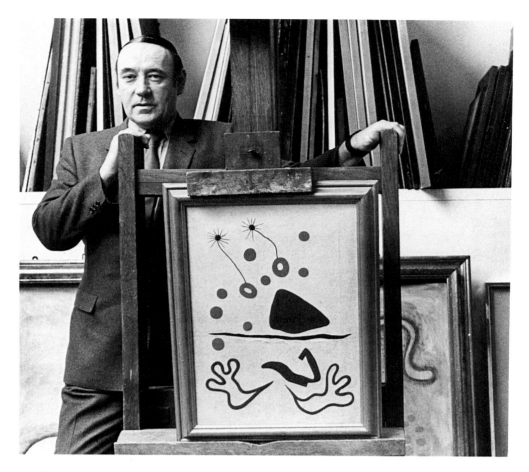

119 In the Oxford studio in 1983. The painting on the easel, **Man Jumping**, 1948, discovered in a London saleroom, had not been seen for thirty-five years.

**1982** In Paris was included in exhibition of British Surrealists at the Galerie 1900–2000, called *Les Enfants D'Alice*. Took third trip around the world. Started work on a lengthy project to investigate the nature of prehistoric art, to be published eventually as a volume entitled *The Art of Ancient Cyprus*. This involved the making of 1,300 drawings of early artefacts, an activity which replaced studio-painting for several years.

**1983** Published a fantasy called *Inrock*. The events in the book take place in a secret world inside the rocks which can be entered only with great difficulty. The Inrock world is peopled by bizarre creatures closely related to the biomorphs in his paintings. The Surrealist story was first written on Cyprus in 1967, re-written on Malta in 1970, and then finally completed in Monaco in 1982. At the end of this year he exhibited a group of paintings in a Christmas show at Wylma Wayne Fine Art in Bond Street, London.

**1985** Published *The Art of Ancient Cyprus*. In London was included in exhibition called *A Salute to British Surrealism 1930–1950*, at Blond Fine Art in Princes Street. Began painting actively again in Oxford Studio.

**1986** Paintings included in the Swansea Festival Exhibition: *Contrariwise*; *Surrealism and Britain 1930–1986* at The Glynn Vivian Art Gallery.

# Checklist of paintings

The following Checklist records all the known surviving paintings, giving in each case the title, medium, dimensions to the nearest inch (height before width), owner, and the figure number in cases where a picture is illustrated in the present volume. If an asterisk follows an entry it indicates that the present whereabouts of the painting is unknown. Where there is no asterisk and no owner's name, the painting is still in the possession of the artist.

In addition to the 508 surviving paintings listed here, a total of 243 are known to have been destroyed by the artist.

These are minimum figures, the real totals being slightly higher, due to the fact that in certain years inadequate records were kept.

In the majority of cases the titles of these paintings are unpremeditated. They are free-association labels attached to the pictures after they have been completed, for purposes of identification. A rare exception to this rule is *The Blind Watchmaker*, 1986 (Fig. 110), which was inspired by the title of a book about the evolutionary process, by Richard Dawkins.

## 1944

1 **Night Music**  Crayon on paper, 5 × 7 in.
2 **Dream-flight**  Crayon on paper, 10 × 8 in.
3 **Sleep**  Crayon on paper, 8 × 13 in.
4 **Chicago**  Crayon on paper, 8 × 13 in.

## 1945

1 **Portrait**  Wax crayons and pencil on paper, 9 × 6 in.

## 1946

1 **The Kiss**  Oil on board, 16 × 13 in.
2 **The Entry of a Siren**  Ink and watercolour on paper, 10 × 8 in.
3 **Sunbath**  Ink and watercolour on paper, 10 × 8 in.
4 **Night Comes**  Ink and watercolour on paper, 10 × 8 in.
5 **They Came to the Door**  Oil on board, 15 × 20 in.*
6 **Over the Wall**  Oil on board, 30 × 26 in.*
7 **Sketch for the Philsopher's Abyss**  Ink and pastel on paper, 8 × 10 in.
8 **The Philosopher's Abyss**  Oil on board, 19 × 24 in.*
9 **Girl Selling Flowers**  Oil on board, 29 × 35 in.
10 **Two Fish in Heaven**  Oil on board, 22 × 29 in.*
11 **The Family**  Oil on board, 28 × 19 in.*
12 **Seated Woman**  Oil on card, 19 × 14 in.
13 **Nightscape**  Oil on board, 14 × 10 in. Collection Mrs Marjorie Morris, Oxford.
14 **Last Drink**  Oil on board, 18 × 14 in.*
15 **The Actress**  Oil on board, 21 × 14 in.*
16 **Aquascape**  Oil on board, 14 × 11 in.*
17 **Woman in an Armchair**  Oil on board, 27 × 16 in. Collection Mr Tony Hubbard.
18 **Knock Once**  Oil on board, 20 × 25 in. Collection Mr John Comely.
19 **Portrait of a Lady**  Oil on board, 22 × 10 in.*
20 **Landscape Without a Memory**  Oil on canvas, 8 × 11 in. Collection Mr Clement Attwood, Swindon.
21 **Christmas Painting**  Oil on board, 24 × 32 in.*
22 **Mother and Child**  Pastel and wax crayon on paper, 10 × 8 in.

## 1947

1 **Portrait**  Pastel on paper, 15 × 12 in.
2 **Portrait**  Pastel on paper, 16 × 11 in.
3 **Four Soldiers**  Pastel on paper, 16 × 11 in.
4 **Portrait**  Pastel on paper, 15 × 11 in.
5 **Cat and Bird Landscape**  Oil on canvas, 9 × 12 in.*
6 **Portrait-landscape**  Oil on card, 16 × 11 in.*
7 **Entry to a Landscape**  Oil on board, 20 × 16 in. *Fig. 4*
8 **The Bride**  Oil on board, 21 × 28 in.*
9 **The Bird Above**  Oil on board, 26 × 33 in.*
10 **Young Woman on a Bus**  Oil on board, 25 × 17 in.*
11 **Discovery of a Species**  Oil on canvas, 19 × 14 in.*
12 **Woman and Two Green Apples**  Oil on board, 16 × 21 in.*
13 **The Illegitimate Dance of the Long-nosed Woman**  Oil on canvas, 12 × 10 in.
14 **Portrait**  Oil on board, 18 × 14 in.*
15 **Kittentrap**  Oil on board, 12 × 16 in.*
16 **Bird Sunscape**  Oil on board, 14 × 21 in.*
17 **Woman Reading**  Oil on card, 16 × 12 in.
18 **Still Life with Fish**  Oil on board, 12 × 12 in.
19 **Giant Instrument for the Production of Synthetic Women**  Oil on canvas, 10 × 8 in.*
20 **Birds and Insects**  Oil on board, 8 × 10 in. Collection Miss Nancy Norris, Swindon.
21 **The Departure**  Oil on board, 14 × 10 in.
22 **The Nest I**  Oil on board, 13 × 17 in. Collection Professor Aubrey Manning, Edinburgh. *Fig. 6*
23 **The Nest II**  Oil on canvas, 13 × 19 in. Private collection, Vienna.
24 **Nude Woman**  Oil on board, 38 × 25 in.*
25 **Portrait of an Actress**  Oil on canvas, 28 × 13 in.*
26 **Portrait of Patricia**  Oil on board, 20 × 16 in. approx. Collection Mr J. Mitchell.
27 **The Widow**  Oil on canvas, 20 × 30 in. approx. Collection Mr Mervyn Levy.
28 **Bird Singing**  Ink and pastel on paper, 11 × 18 in.
29 **Moonscape**  Oil on card, 10 × 8 in.
30 **Landscape for a Para-introvert**  Oil on card, 14 × 18 in. Collection Mr Hugh Clement, Wales. *Fig. 7*

31 **Master of the Situation** Oil on canvas, 16 × 12 in. Collection Mr Alasdair Fraser, London. *Fig. 5*

**1948**

1 **Confrontation** Oil on canvas, 18 × 12 in. *Fig 8*
2 **Hypnotic Painting** Oil on canvas, 13 × 28 in.
3 **Reclining Nude** Oil on canvas, 15 × 30 in. Collection Mr Gordon Harris, London.
4 **The Encounter** Oil on canvas, 6 × 8 in.
5 **The Parent** Oil on canvas, 6 × 8 in.*
6 **The Lovers** Oil on canvas, 8 × 6 in. *Fig. 9*
7 **Red Landscape** Oil on board, 13 × 27 in.*
8 **The Green Sprite** Oil on canvas, 8 × 6 in.
9 **The Dreaming Cretin** Oil on board, 14 × 19 in.*
10 **Celebration** Oil on board, 28 × 37 in. *Fig. 11*
11 **The Dove** Oil and plaster on canvas, 23 × 26 in. *Fig. 14*
12 **L'Enfant Terrible** Oil on canvas, 27 × 23 in.*
13 **The Edge of the World** Oil on canvas, 12 × 16 in.*
14 **Man and Machine** Oil, pastel, ink and pencil on paper, 9 × 7 in.
15 **The Hermit Discovered** Oil on canvas, 16 × 22 in.
16 **Flower Machine** Oil on canvas, 20 × 26 in.*
17 **The Hunter** Oil and plaster on canvas, 17 × 21 in. Collection Mr Paul Conran, London. *Fig. 15*
18 **The Green Forest** Oil on canvas, 10 × 16 in.*
19 **The Red Flower** Oil on board, 10 × 7 in.
20 **The Suicide** Oil on glass, 8 × 11 in. Collection Mr Peter Carreras.
21 **Flower Woman Machine** Oil on canvas, 14 × 7 in.*
22 **The Encounter** Oil on canvas, 8 × 16 in.
23 **Man Jumping** Oil on canvas, 21 × 16 in. Collection Mr Gordon Harris, London. *Fig. 119*
24 **The Love Letter** Oil on canvas, 20 × 16 in.
25 **The Voyager** Oil. Collection Mr Tony Stevens.
26 **The Close Friend** Oil on canvas, 26 × 20 in. Collection Dr John Treherne, Cambridge. *Fig. 13*
27 **The Red Dancer** Oil and pastel on card, 18 × 13 in. *Fig. 12*
28 **Red and Orange Situation** Oil on card, 16 × 12 in.
29 **The Courtship I** Oil on canvas, 54 × 38 in. *Fig. 10*
30 **The Table** Oil on canvas, 14 × 18 in. Phipps and Company Fine Art, London. *Fig. 16*
31 **The Courtship II** Oil on canvas, 14 × 19 in. Private collection, Vienna.
32 **Owl** Chalk and ink on paper, 15 × 11 in.
33 **Informal Landscape** Ink, crayon and pastel on paper, 8 × 6 in.
34 **Statue** Ink and pastel on paper, 16 × 12 in.
35 **Two Figures** Crayon and pastel on paper, 11 × 8 in.
36 **The Princess** Oil and ink on paper, 13 × 8 in.

**1949**

1 **The Desiccation of the Poet** Gouache on card, 9 × 7 in.
2 **The Jumping Three** Oil on canvas, 30 × 50 in.
3 **Colony Relations** Watercolour on paper, 10 × 7 in.
4 **Acrobatic Dispute** Gouache on paper, 9 × 12 in.
5 **The Suicides** Oil on board, 50 × 30 in.*
6 **The Observer** Oil on canvas, 17 × 22 in.*

7 **The Inhabitants** Oil on canvas, 10 × 16 in. Private collection, Berkshire. *Fig. 20*
8 **The Intruder** Oil on card, 12 × 16 in. Collection Mr Paul Weir, Wroughton, Wiltshire. *Fig. 17*
9 **Design for a Statue** Oil on board, 34 × 25 in.*
10 **Farewell** Oil on canvas, 30 × 25 in.*
11 **The Visitor** Oil on canvas, 9 × 12 in.*
12 **The Actors** Oil on board, 11 × 13 in.*
13 **The Restless Soldiers** Gouache on paper, 6 × 10 in.
14 **The Lookouts** Gouache on paper, 6 × 9 in.
15 **The Explorer** Gouache on card, 7 × 18 in.*
16 **The Assault** Oil on board, 18 × 29 in.*
17 **The Bathers I** Oil on paper, 8 × 13 in.*
18 **Family on the Beach** Oil on paper, 7 × 12 in. Collection Dr Philip Guiton, Les Eyzies, France.
19 **Only the Guest is at Ease** Oil on paper, 10 × 15 in.
20 **The Bathers II** Oil on paper, 8 × 13 in.
21 **Ageing Dancer** Oil on paper, 8 × 13 in.
22 **Storm Coming** Oil, 7 × 10 in.*
23 **The Apple-pickers** Oil and indian ink on paper, 8 × 13 in. Collection Mr Philip Oakes, London. *Fig. 18*
24 **The Fatal Attraction of the Poet** Oil on paper, 8 × 13 in.
25 **Moonscape** Oil and pastel on paper, 8 × 13 in.*
26 **The Farmer** Oil on board, 8 × 12 in.*
27 **The Monster** Oil on paper, 5 × 6 in.*
28 **Work Force** Oil and gouache on paper, 8 × 13 in.
29 **St George and the Dragon** Oil on paper, 8 × 13 in.
30 **St George** Oil on paper, 8 × 13 in.
31 **Dragon** Oil on paper, 7 × 8 in.
32 **The Nest IV** Oil on paper, 7 × 11 in.*
33 **The Herd** Oil on card, 29 × 48 in.
34 **The Daymare Begins** Oil on paper, 8 × 13 in. approx.*
35 **The Family** Mixed media.*
36 **Siblings** Oil on paper, 10 × 14 in.
37 **War-woman** Mixed media on board, 28 × 17 in. *Fig. 19*
38 **The Proposal** Oil on paper, 14 × 9 in.
39 **The Witness** Mixed media on board, 9 × 13 in.
40 **The Red Ritual** Oil on board, 14 × 22 in. approx. Collection Mr Tony Hubbard.
41 **Cat I** Oil on paper, 13 × 8 in. Collection Dr John Treherne, Cambridge.
42 **Cat II** Oil on paper, 13 × 8 in. Collection Mr Oscar Mellor, Exeter.
43 **Cat III** Oil on paper, 13 × 8 in. Collection Mr Oscar Mellor, Exeter.
44 **Cat IV** Oil on paper, 13 × 8 in.*
45 **Cat V** Oil on paper, 13 × 8 in. Private coll., Reading.
46 to 60 **Cat VI to XX** Oil on paper, all 13 × 8 or 8 × 13 in.
61 **King** Oil on paper, 13 × 8 in.*
62 **Dog, Man and Woman** Oil on paper, 8 × 13 in. Collection Mr Paul Weir, Wroughton, Wiltshire.
63 **Acrobat** Oil on paper, 13 × 8 in. Collection Mr Paul Weir, Wroughton, Wiltshire.
64 **Creating a Disturbance** Oil and gouache on paper, 7 × 12 in. Collection Mr Oscar Mellor, Exeter.
65 **Reclining Nude** Oil on paper, 5 × 13 in. Collection Mr Hugh Clement, Wales.

**1953–1954** No surviving paintings.

**1955**

1 **Portrait of a Thinking Girl** Oil on card, 18 × 13 in.

**1956**

1 **Woman with Birds** Oil on canvas, 9 × 12 in. Collection Mrs Ramona Morris, Oxford. *Fig. 31*
2 **Keep Together** Oil on canvas, 7 × 14 in.
3 **The Parade** Oil on canvas, 7 × 14 in.

**1957**

1 **The Indelible Incident** Oil on canvas, 7 × 14 in.
2 **Cyclists** Oil on canvas, 7 × 14 in.*
3 **City Games** Oil on canvas, 7 × 14 in.
4 **The Performers** Oil on canvas, 7 × 14 in. Collection Mrs Marjorie Morris, Oxford.
5 **Totem** Oil on canvas, 7 × 14 in. Collection Mrs Marjorie Morris, Oxford.
6 **The Colony** Oil on canvas, 7 × 14 in.
7 **The Blind Leader** Oil on canvas, 7 × 14 in. Collection Mrs Marjorie Morris, Oxford.
8 **The Silent Gathering** Oil on board, 7 × 14 in.
9 **The Sacrifice** Oil on canvas, 7 × 14 in. Collection Mrs Marjorie Morris, Oxford.
10 **The Enclosure** Oil on canvas, 7 × 14 in. *Fig. 33*
11 **Fear of the Past** Oil on canvas, 7 × 14 in.
12 **There's No Time Like the Future** Oil on canvas, 7 × 14 in. Collection Mrs Marjorie Morris, Oxford.
13 **The Spanish Table** Oil on canvas, 7 × 14 in. Collection Dr Gilbert Manley, Durham. *Fig. 32*
14 **Dragon Patrol** Oil on canvas, 7 × 14 in.
15 **The Charioteer** Oil on canvas, 7 × 14 in. Collection Mr Michael Lyster, London.
16 **Alter Ego** Oil on canvas, 7 × 14 in.*
17 **Two Heads are Worse than One** Oil on canvas, 7 × 14 in.*
18 **Private Body** Oil on canvas, 7 × 14 in.*
19 **The Courtyard Drama** Oil on canvas, 7 × 14 in.*
20 **The Victor** Oil on canvas, 7 × 14 in.*
21 **The Eager Anticipants** Oil on canvas, 7 × 14 in.*
22 **The Playground of Power** Oil on canvas, 7 × 14 in. Private collection, Berkshire.
23 **Training Ground** Oil on canvas, 7 × 14 in. Private collection, Berkshire.
24 **The Bond of Mutual Distrust** Oil on canvas, 7 × 14 in.*
25 **A Longstanding Hateship** Oil on canvas, 7 × 14 in.*
26 **The Antagonists** Oil on canvas, 7 × 14 in.*
27 **Rite de Passage** Oil on canvas, 7 × 14 in. Private collection, Berkshire.
28 **Interrupted Game** Oil on canvas, 7 × 14 in.*

**1958**

1 **Bird Warning** Oil on board, 9 × 10 in.
2 **Night Beast** Oil on canvas, 7 × 14 in.
3 **The Serpent's Choice** Oil on canvas, 7 × 14 in.
4 **Spinster in the Spring** Oil on canvas, 7 × 14 in.

5 **The Birdcatcher** Oil on canvas, 7 × 14 in.
6 **The Orator's Moment** Oil on canvas, 7 × 14 in.
7 **The White Horse** Oil on canvas, 7 × 14 in.
8 **Family Relations** Oil on canvas, 13 × 36 in.
9 **Premonition of Life** Oil on canvas, 11 × 16 in.
10 **Monster Manqué** Oil, ink and watercolour on paper, 8 × 12 in.
11 **Four Figures** Oil and ink on paper, 8 × 13 in.
12 **Extinction Beckons** Oil and ink on paper, 8 × 10 in.

**1959**

1 **The Revolt of the Pets** Oil on canvas, 10 × 12 in. *Fig. 34*
2 **Virtuoso without an Audience** Coloured inks on paper, 10 × 14 in.
3 **Woman with a Cruel Past** Oil and ink on paper, 8 × 13 in.

**1960**

1 **Loving Couple** Oil and ink on paper, 11 × 9 in.
2 **Day-starved Mannerisms** Oil and ink on board, 24 × 36 in.
3 **Don't Leave Me Here** Coloured inks on paper, 14 × 10 in.
4 **The Expansive Invitation** Coloured inks on paper, 11 × 8 in.
5 **Rites of Winter** Coloured inks on paper, 10 × 14 in.
6 **Yesterday Went Quickly** Coloured inks on paper, 13 × 10 in.
7 **False Appearances** Ink and wash on paper, 10 × 8 in.
8 **Best Man Loses** Coloured inks on paper, 9 × 11 in.
9 **The Finder** Oil and ink on paper, 14 × 10 in.
10 **Declamation of Bias** Coloured inks on paper, 11 × 10 in.
11 **Exodus Blues** Coloured inks on paper, 8 × 11 in.
12 **The Egg-thieves** Oil and plaster on canvas, 14 × 17 in. Collection Mr Tom Maschler, London. *Fig. 35*
13 **The Killing Game** Oil and plaster on canvas, 16 × 20 in.
14 **Family Group** Oil on canvas, 22 × 25 in.
15 **Figure with Birds** Oil on canvas, 20 × 24 in. approx.*
16 **Woman with Birds** Oil on canvas, 20 × 24 in. approx.*
17 **Two Women with Bird** Oil on canvas, 24 × 20 in. approx.*
18 **Self-portrait** Oil on canvas, 24 × 20 in. approx.* *Fig. 115*
19 **The Assembly** Oil and plaster on board, 34 × 84 in.
20 **The New Arrival** Oil on canvas, 20 × 30 in. Collection Mrs Mary Horswell, Windsor.

**1961**

1 **Processional** Oil and plaster on board, 12 × 96 in. *Fig. 1*
2 **Three Rivals** Oil on canvas, 19 × 23 in.
3 **First Love** Oil on canvas, 13 × 27 in.
4 **Nest-figure** Oil and plaster on canvas, 26 × 12 in.
5 **White Landscape I** Oil and plaster on canvas, 20 × 24 in.

6 **White Landscape III** Oil and plaster on board, 13 × 18 in.

7 **White Landscape VII** Oil and plaster on board, 13 × 16 in.

8 **White Landscape VIII** Oil and plaster on board, 12 × 16 in.

9 **White Landscape IX** Oil and plaster on board, 16 × 22 in.

10 **White Landscape XI** Oil and plaster on board, 14 × 21 in.

11 **White Landscape XII** Oil and plaster on board, 14 × 21 in.

12 **White Landscape XIII** Oil and plaster on board, 20 × 25 in.

13 **Moment of Judgement** Oil and plaster on board, 24 × 12 in.

14 **The New Challenge** Oil and plaster on board, 24 × 15 in.

15 **The Ruling Power** Oil and plaster on board, 24 × 12 in.

16 **The Dominion of Vulgar Piety** Oil and plaster on board, 14 × 7 in.

17 **The Pimple on the Face of Art is Really a Beauty Spot** Oil and plaster on board, 14 × 7 in.

18 **The Beautiful Behind of the Dog-faced Girl is not Appealing** Oil and plaster on board, 14 × 7 in.

19 **The Predator Smells of Lavender** Oil and plaster on board, 14 × 7 in.

20 **The Intepreter is Late Again** Oil and plaster on board, 16 × 8 in.

21 **The Great Populator** Oil on paper, 19 × 26 in.

22 **Cell-head I** Oil on card, 18 × 14 in. *Fig. 36*

23 **Cell-head II** Oil on paper, 12 × 16 in.

24 **Cell-head III** Oil on paper, 12 × 16 in.

25 **Cell-head IV** Oil on paper, 15 × 20 in.

26 **Cell-head V** Oil on paper, 22 × 17 in.

27 **Cell-head VI** Oil on paper, 21 × 17 in.

28 **The Child of Nocturnal Occasions** Oil on canvas, 8 × 14 in.

29 **Festive Symbols** Oil and plaster on canvas, 8 × 12 in.

30 **Lost Friend** Oil and plaster on board, 14 × 7 in.

31 **Cell-head VII** Oil on card, 20 × 15 in. *Fig. 37*

32 **The Philsopher has Lied** Oil and plaster on board, 24 × 12 in.

33 **Cell-head VIII** Oil on board, 19 × 15 in.

34 **Cell-head IX** Oil on paper, 10 × 15 in.

35 **Cell-head X** Oil on paper, 15 × 22 in.

36 **Cell-head XI** Oil on paper, 16 × 10 in.

37 **Cell-head XII** Oil on paper, 16 × 10 in.

38 **Cell-head XIII** Oil on paper, 16 × 10 in.

39 **Cell-head XIV** Oil on paper, 26 × 18 in.

40 **Cell-head XV** Oil on paper, 10 × 14 in.

41 **Cell-head XVI** Oil on board, 18 × 14 in. approx.*

42 **Cell-head XVII** Oil on paper, 16 × 10 in.

43 **Cell-head XIX** Oil on board, 36 × 24 in.

44 **Cell-head XX** Oil on paper, 10 × 12 in.

45 **Cell-head XXI** Oil on paper, 23 × 17 in.

46 **Cool Head** Oil on paper, 18 × 25 in.

47 **Egghead I** Oil and plaster on board, 18 × 24 in. *Fig. 38*

48 **Cell-head XXII.** Oil on board, 20 × 15 in.

49 **The Diversity of Personal Surprise** Oil and plaster on board, 24 × 15 in.

50 **Lovejoy and Killjoy** Oil and plaster on board, 24 × 15 in.

51 **Force of Fusion** Oil on canvas, 16 × 12 in. *Fig. 39*

52 **Growing Point** Oil on board, 36 × 24 in.

53 **Fertilization I** Oil on board, 41 × 35 in.

54 **Fertilization II** Oil on board, 39 × 30 in. *Fig. 40*

55 **Ovulation** Oil on canvas, 29 × 22 in. *Fig. 41*

56 **The Addiction of Privacy** Oil on canvas, 30 × 20 in. *Fig. 42*

57 **Cell-head XXIII** Oil on board, 21 × 14 in.

58 **Cell-head XXIV** Oil on board, 28 × 38 in.

**1962**

1 **Splitting Head** Oil on canvas, 19 × 14 in.

2 **The Offering** Oil on card, 26 × 32 in.

3 **Indigenous Head** Oil on board, 36 × 24 in.

4 **Hardhead** Oil on board, 36 × 24 in.

5 **Cell-head XXV** Oil on canvas, 26 × 20 in.

6 **Cell-head XXVI** Oil on board, 27 × 15 in.

7 **Cell-head XXVII** Oil on card, 28 × 20 in.

8 **Cell-head XXVIII** Oil on canvas, 22 × 29 in.

9 **Fertilization III** Oil on canvas, 16 × 12 in.

10 **Children of Fortune** Oil on canvas, 15 × 11 in.

11 **Red Riding Shock** Oil on canvas, 16 × 44 in.

12 **Egghead II** Oil and plaster on board, 20 × 25 in.

13 **Willing Victim** Oil and plaster on board, 24 × 12 in.

14 **Point of Contact** Oil and plaster on board, 24 × 18 in. *Fig. 43*

15 **Simple Pleasures** Oil on board, 32 × 43 in.

16 **Game Signs** Oil and plaster on board, 24 × 34 in.

17 **Sex-starved Banker Fleeing from Vision of Horned Snakes** Oil on board, 25 × 18 in.

18 **Egghead III** Oil and plaster on board, 18 × 24 in.

19 **Egghead IV** Oil and plaster on board, 18 × 24 in.

**1963** No surviving paintings.

**1964**

1 **Boundary Dispute** Mixed media on board, 24 × 18 in.

2 **Bold Moment** Oil on board, 25 × 23 in.

3 **Landscape** Oil on board, 29 × 23 in.

**1965**

1 **Parasite in the House** Oil on board, 36 × 24 in.

2 **The Translator's Whim** Oil on canvas, 40 × 24 in.

3 **Climactic Mirage** Oil on board, 36 × 24 in.

4 **The Morphology of Envy** Oil on board, 36 × 24 in.

5 **The Mysterious Gift** Oil on canvas, 39 × 28 in. Swindon Art Gallery. *Fig. 44*

6 **Ambiguous Offering** Oil on canvas, 54 × 37 in. *Fig. 45*

**1966**

1 **Ceremonial Pastimes** Oil on board, 14 × 21 in.

2 **Before the Bang** Oil on canvas, 29 × 22 in.

3 **Pair Bond** Oil on board, 10 × 14 in.
4 **Proud Figure** Oil on canvas, 24 × 17 in.
5 **Strong Figure** Oil on canvas, 25 × 21 in.
6 **The Day of the Zygote** Oil on canvas, 20 × 16 in.
7 **Guard Figure** Oil on wood, 17 × 13 in.
8 **Intimate Decision** Oil and plaster on canvas, 18 × 15 in. *Fig. 48*
9 **Organic Statue** Oil on card, 17 × 21 in. *Fig. 51*
10 **Beast of Burden** Oil on canvas, 54 × 72 in.
11 **Lonely Quadruped** Oil on board, 17 × 20 in.
12 **Growing Signals** Oil on canvas, 21 × 14 in.
13 **Body Flower** Oil on canvas, 33 × 23 in. *Fig. 46*
14 **Introvert** Oil on canvas, 24 × 20 in. *Fig. 47*
15 **Figure of Some Importance** Oil on canvas, 32 × 25 in.
16 **Days of Quantity** Oil on board, 25 × 30 in.
17 **Warrior Waiting** Oil on board, 24 × 18 in. *Fig. 49*
18 **Extrovert** Oil on canvas, 36 × 48 in. *Fig. 50*
19 **The Hidden Stimulus** Oil and plaster on board, 24 × 18 in.
20 **Coupling Strategies** Oil on panel, 10 × 14 in.
21 **Fine Figure** Oil on canvas, 19 × 15 in. Collection Mrs Marjorie Morris, Oxford.

**1967** No surviving paintings.

**1968**
1 **The Debris of Fixations** Oil on board, 48 × 60 in.
2 **Posture of Dominance** Oil on board, 72 × 48 in.
3 **A Lapse of Heart** Oil on board, 45 × 60 in.
4 **Resting Goddess** Oil on board, 45 × 60 in.
5 **Beneath the Censor** Oil on board, 46 × 60 in.
6 **Nuptial Display** Oil on board, 29 × 23 in.
7 **The Adviser** Oil on board, 32 × 27 in.
8 **The Antagonist** Oil on board, 32 × 27 in.

**1969**
1 **Table Pleasures** Oil on board, 45 × 59 in. *Fig. 53*
2 **Festival** Oil on board, 45 × 60. *Fig. 56*
3 **Birthday Emotions** Oil on board, 33 × 27 in. *Fig. 54*
4 **Daydream Zone** Oil on board, 33 × 27 in. *Fig. 55*
5 **The Scale of Amnesia** Oil on board, 29 × 24 in.
6 **Mother Goddess** Oil on card, 20 × 15 in.
7 **Earth Mother** Oil on board, 29 × 29 in. *Fig. 52*
8 **Rival Deities** Oil on board, 27 × 48 in.
9 **Fertility Figure** Oil on board, 28 × 47 in.
10 **Great Mother** Oil on board, 28 × 25 in.
11 **The Teacher's Doubt** Oil on canvas, 12 × 26 in. *Fig. 57*
12 **The Explorer has Arrived** Oil on canvas, 8 × 12 in. Collection Sir David Attenborough, London. *Fig. 58*
13 **The Ritual** Oil on canvas, 24 × 36 in. Private collection, London. *Fig. 59*

**1970**
1 **Neophilic Excitements** Oil on board, 45 × 59 in.
2 **The Entertainer** Oil on board, 29 × 23 in.
3 **Greenery Pastimes** Oil on board, 45 × 59 in. *Fig. 118*
4 **Restraints of Kinship** Oil on board, 45 × 59 in.
5 **Until It's Time To Go** Oil on canvas, 10 × 12 in. approx.*

**1971**
1 **Festa Day** Ink and pastel on board, 12 × 15 in.

**1972**
1 **The Titillator** Oil on canvas, 12 × 18 in. Collection Dr Richard Dawkins, Oxford. *Fig. 76*
2 **The Attentive Friend** Oil on canvas, 12 × 18 in. Collection Mrs Marjorie Morris, Oxford *Fig. 60*
3 **The Unimportance of Yesterday** Oil on canvas, 12 × 18 in. *Fig. 62*
4 **The Protector** Oil on canvas, 16 × 22 in. Collection Equinox Ltd, Oxford. *Fig. 64*
5 **Sting Appeal** Oil on canvas, 12 × 18 in. Collection Dr Kate MacSorley, London. *Fig. 65*
6 **The Onlookers** Oil on board, 11 × 21 in. Collection Mr Herman Friedhoff, Oxford. *Fig. 66*
7 **The Ceremony of the Hole** Oil on canvas, 20 × 30 in. *Fig. 67*
8 **The Fertility of Pain** Oil on canvas, 20 × 30 in. *Fig. 68*
9 **The Visitor** Oil on canvas, 12 × 16 in. *Fig. 69*
10 **The Gravidity of Power** Oil on canvas, 20 × 30 in.
11 **The Three Members** Oil on canvas, 12 × 18 in. *Fig. 74*
12 **Polymorphic Growth** Oil on canvas, 12 × 18 in. Collection Mrs Helen Profumo, London. *Fig. 70*
13 **The Protégé** Oil on board, 10 × 8 in. *Fig. 73*
14 **The Expectant Valley** Oil on canvas, 24 × 30 in. Collection Dr Richard Dawkins, Oxford. *Fig. 77*
15 **The Guardian of the Cycle** Oil on canvas, 12 × 18 in. *Fig. 61*
16 **The Parade of Memories** Oil on canvas, 20 × 30 in. *Fig. 78*
17 **The Insensitive Intruder** Oil on canvas, 12 × 16 in. *Fig. 63*
18 **Dyadic Encounter** Oil on canvas, 20 × 30 in. *Fig. 71*
19 **The Obsessional Meal** Oil on canvas, 12 × 18 in. Collection Mr Richard Veen, Amsterdam. *Fig. 75*
20 **The Collector's Fallacy** Oil on canvas, 24 × 30 in. Private collection, London. *Fig. 72*

**1973**
1 **Stop Them If You Can** Oil on canvas, 24 × 30 in.
2 **The Observers** Oil on canvas, 20 × 30 in. *Fig. 86*
3 **The Mediator** Oil on board, 10 × 8 in.
4 **The Agitator** Oil on board, 10 × 8 in. *Fig. 81*
5 **For Insiders Only** Oil on canvas, 16 × 22 in. Collection Professor E.V. van Hall, Noordwijk, Holland. *Fig. 87*
6 **Lovers' White Dreamtime** Oil on canvas, 24 × 30 in. Collection Mr and Mrs James Vaughn Jnr, Texas. *Fig. 88*
7 **The Perennial Discovery** Oil on canvas, 12 × 16 in.
8 **The Well-groomed Bride** Oil on canvas, 22 × 16 in. *Frontispiece*
9 **Disturbance in the Colony** Oil on canvas, 20 × 30 in. Collection Mrs Marjorie Morris, Oxford. *Fig. 83*
10 **The Neglected Rival** Oil on canvas, 20 × 30 in. Collection Equinox Ltd, Oxford. *Fig. 84*
11 **The Familiar Stranger** Oil on canvas, 20 × 30 in. *Fig. 85*
12 **The Erosion of Longing** Oil on canvas, 16 × 22 in. Collection Mr Hans Redmann, West Berlin. *Fig. 82*

13 **Deciduous Decisions** Oil on canvas, 12 × 16 in. *Fig. 79*
14 **The Kill** Oil on canvas, 20 × 30 in. Collection Christopher Moran and Co Ltd, London. *Fig. 93*
15 **The Last Breakfast** Oil on canvas, 12 × 16 in. Private collection, London.
16 **The Guardian of the Trap** Oil on canvas, 20 × 36 in. *Fig. 89*
17 **The Audience Discovers it is the Performance** Oil on canvas, 20 × 36 in. Private collection, Oxfordshire. *Fig. 90*
18 **The Day After Yesterday** Oil on canvas, 12 × 16 in. *Fig. 92*
19 **Edgy** Oil on board, 24 × 36 in. Private collection, London.
20 **The Budding Force** Oil on canvas, 16 × 12 in. Private collection, Oxfordshire. *Fig. 80*
21 **The Moment of Partial Truth** Oil on canvas, 20 × 36 in. *Fig. 91*

## 1974

1 **Metamorphic Landscape** Oil on board, 23 × 29 in. Collection Sir David Attenborough, London. *Fig. 94*

**1975** No surviving paintings.

## 1976

1 **Contestants** Oil on canvas, 24 × 36 in. *Fig. 99*
2 **Private Figure** Oil on board, 10 × 7 in. *Fig. 95*
3 **Ancestors** Oil on panel, 20 × 22 in. Collection Mr Herman Friedhoff, Oxford. *Fig. 98*
4 **Public Figure** Oil on board, 16 × 12 in. *Fig. 96*
5 **The Presentation** Oil on canvas, 24 × 36 in. *Fig. 97*
6 **The Arena** Oil on canvas, 24 × 36 in. *Fig. 100*

7 **The Sentinel** Oil on canvas, 24 × 36 in. Collection Mr H. Slewe, Laren, Holland. *Fig. 103*
8 **Ascending Figure** Oil on canvas, 24 × 36 in. *Fig. 101*
9 **Totemic Decline** Oil on canvas, 24 × 36 in. *Fig. 102*
10 **The Sleepwalker** Oil on canvas, 24 × 36 in. *Fig. 104*

**1977–1980** No surviving paintings.

## 1981

1 **Aggro** Oil on canvas, 24 × 36 in. Collection Dr and Mrs Peter Marsh, Oxford. *Fig. 105*

**1982–1984** No surviving paintings.

## 1985

1 **Brown Figure I** Oil on board, 10 × 7 in. *Fig. 107*
2 **Brown Figure II** Oil on board, 10 × 7 in. *Fig. 108*
3 **Hybrid Vigour** Oil on board, 10 × 7 in. *Fig.106*
4 **The Seven Sisters** Oil on board, 24 × 36 in. *Fig. 109*
5 **January 24th** Mixed media on paper, 8 × 8 in. Collection Andrew Jones Art, London.

## 1986

1 **The Blind Watchmaker** Oil on canvas, 30 × 24 in. *Fig. 110*
2 **The Orator** Oil on board, 10 × 7 in. *Fig. 111*
3 **The Red Guard** Oil on canvas, 24 × 36 in.
4 **The Usher** Oil on canvas, 12 × 16 in. *Fig. 112*
5 **The Illusionist** Oil on canvas, 16 × 12 in.
6 **The Bipedal Surprise** Oil on canvas, 22 × 18 in.
7 **Protean Diversions** Oil on canvas, 16 × 22 in.
8 **Seasonal Positions** Oil on canvas, 24 × 36 in.
9 **Green Landscape** Oil on panel, 20 × 22 in.

# Index